For Lex, Ginger, Bonny and everlasting George.

Published in 2021 by Melbournestyle Books
155 Clarendon Street, South Melbourne
Victoria 3205, Australia
www.melbournestyle.com.au

 A catalogue record for this book is available from
the National Library of Australia
National Library of Australia Cataloguing-in-Publication entry:

Coote, Maree, author, illustrator.

Letterheads: Typographic Portraits / Maree Coote, author,
illustrator.

ISBN 978-0-6485684-3-8 (pbk.)

Subjects:
1. Music–Rock Stars–Pop stars–Pictorial works
1. Historic Figures–Artists–Politicians–Pictorial works
2. Fine Arts: Treatments & Subjects
3. Alphabet in Art–pictorial works
4. Graphic Design (Typography)–general interest
5. Picture puzzles–general interest
6. English language–Alphabet
7. Fontigram–Letter Art–Typography
8. Maree Coote–Illustrator
9. Australian

10 9 8 7 6 5 4 3 2 1

MELBOURNESTYLE
AUSTRALIA

www.melbournestyle.com.au

FONTIGRAM

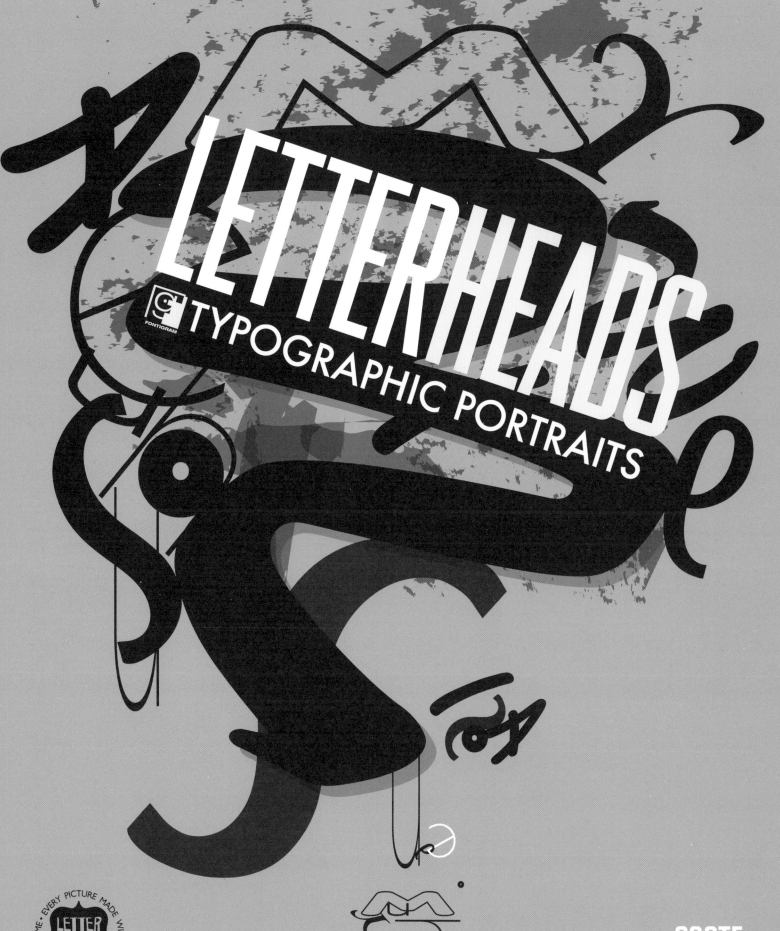

LETTERHEADS

TYPOGRAPHIC PORTRAITS

FONTIGRAM

LETTER ART

EVERY PICTURE MADE WITH THE LETTERS OF ITS OWN NAME

COOTE

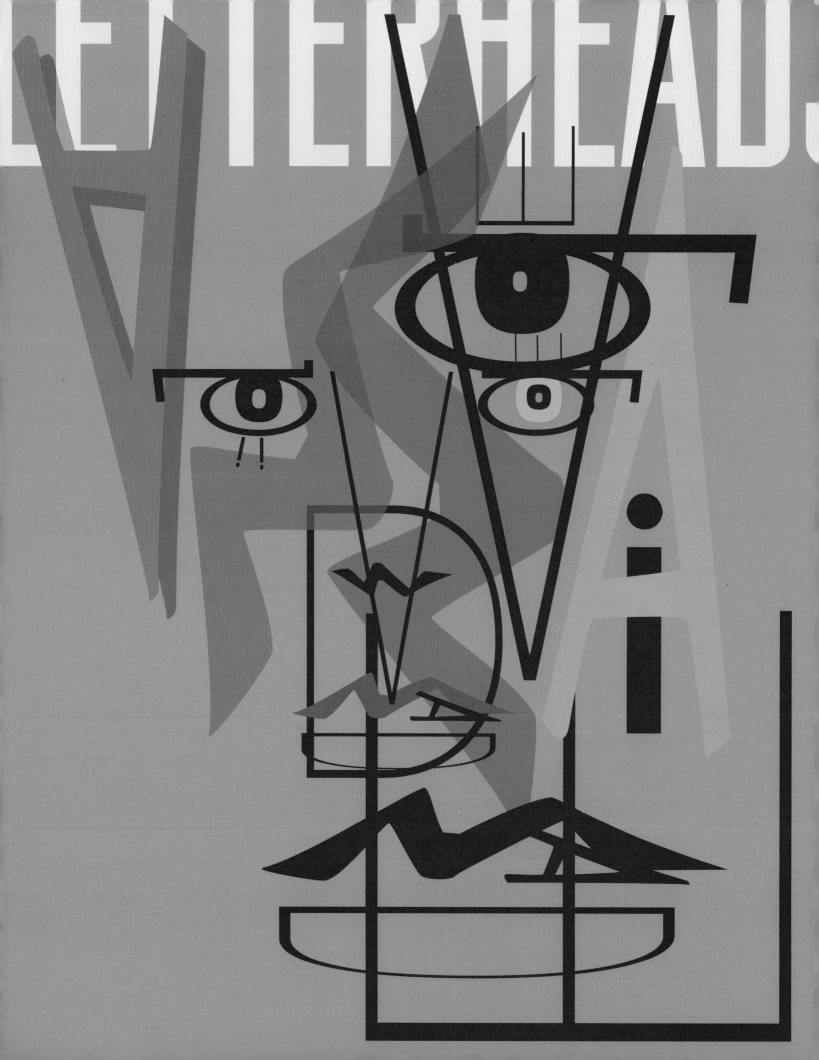

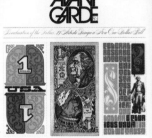

Herb Lubalin Monogram, (tribute design by Alan Peckolick), 1985 Courtesy Herb Lubalin Study Center
Artone 'A' by Seymour Chwast, 1964
Avant Garde Magazine Vol.3, by Tom Carnese, Gerry Gersten & Herb Lubalin, 1968.
Courtesy Herb Lubalin Study Center

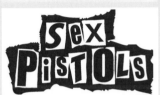

Movie title by Saul Bass, 1955
Sex Pistols logo by Jamie Reid, 1975
Hot metal slugs from a Linotype setting machine, c1965
The Mouse's Tale from Lewis Carroll's Alice's Adventures In Wonderland, 1865
The Critic by Kurt Schwitters, 1921

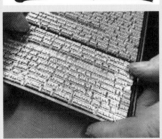

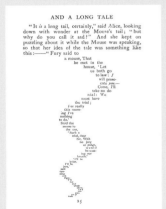

PREFACE

I owe my passion for type to a cohort of New Yorkers whose playful typographics wallpapered my youth. In the 1960s and '70s, Milton Glaser, Seymour Chwast, Herb Lubalin, Ed Benguiat, Saul Bass and others had been redefining visual culture for a couple of decades. Glaser and Chwast had begun their powerhouse collaboration Push Pin Studios in 1954, Bass was the master of the mid-century movie title, and Lubalin a designer of groundbreaking magazine typographics. Their work was overtly illustrative, humanistic and expressionist. They raided the imagery of Art Nouveau, Deco and Victoriana, rehashing it with humour and irreverence. They invaded both the mainstream and counterculture with labyrinthine letters, mind-bending animations and powerful political visual ideas. This work was all around me, and I breathed it in like air without any real awareness of its source or its power. Worlds away from New York in my home city of Melbourne it was designer/animator Alex Stitt who joined those ranks with equal skill and ubiquity. By the 1980s when I began my own design career, Neville Brody (UK) and David Carson (USA) had appeared, iconoclastic and revolutionary, and type took an unmissable turn towards Grunge and Punk. Back then the world of type was overwhelmingly male, trailing behind the Mad Man tradition of advertising, newspapers and printers, and it took me a long while to find both the work and the names of women type designers Zuzana Licko, Carol Twombly and Barbara Klunder, designer Paula Scher and type historian Nicolete Gray.

As the daughter of a journalist, the rattling hum of the newspaper compositing room remains a vivid childhood memory. Hot metal slugs and wooden display letters became arcane souvenirs from a strange planet of linotype machines, shimmering molten lead and cigarette smoke. That early glimpse of typesetting gave me a singular appreciation for my cloth-bound copy of Alice's Adventures in Wonderland, which contained a very arresting oddity: a typeset rendition of The Mouse's Tale, my first encounter with creative shape-setting. A decade later, during my graphic design training at RMIT University, I discovered this was in fact called Concrete Poetry, and that there were endless possibilities for such creativity with type. Enthralled by the stylings of the Dadaists and Surrealists, I was finally officially introduced to the irresistible links between letters, words, poetry and art. The first few years of my role as an advertising Art Director in the pre-Mac 1980s were spent wildly collaging images into letters, hacking Letraset, and manipulating photocopiers by surfing the light beam to stretch and distort images, or by simply re-copying solid blacks ad nauseam until they had degraded into little more than amplified paper pulp. So I was more than ready for my first Apple Macintosh in 1984, which delivered unprecedented control over typography directly into the hands of the designer. Suddenly it became effortless to change the shape and structure of digitised type, to re-size, expand, condense and elongate, to shade, overlay, or distort letters, headlines and paragraphs, all at the touch of a keystroke. Before long, desktop tech had delivered me all the resources I needed to create, manufacture and publish projects of my own – quite outside of my advertising work – on history, contemporary culture, art and design, and my work eventually gravitated more and more to publishing.

TYPOGRAPHY BASICS

"WORDS HAVE MEANING, TYPE HAS SPIRIT.
THE COMBINATION IS SPECTACULAR."

–PAULA SCHER, designer, Pentagram

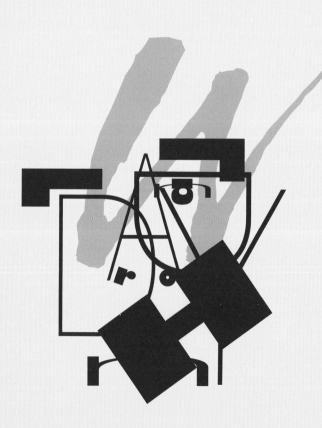

The endless variation in typeface design is linked to the technology of the day. As history and human ingenuity develop new means for the dissemination of ideas, these in turn create new possibilities for type, both practical and creative. The resulting proliferation of font designs is born from the two fundamentals of good design: Form and Function, or as they are expressed in the world of type, Style and Legibility.

Legibility is relative and depends on what we're used to reading. It changes continually, making the best of available technology and medium: from carving to calligraphy, from Gutenberg's press to the typewriter, from the PC to the iPhone. Legibility is manipulated by all the specific choices of the typographer including: sans serif vs serif, tracking, leading, kerning, stroke weight, x-height, paragraph colour, ligatures, and so on. (Glossary p.117)

Style, on the other hand, is all about expressing mood and emotion in the message. It is connected to fashion, politics, art, music, society and trends, and a study of type through the ages shows typefaces are always reflective of the zeitgeist: Deco and Punk offer two obvious examples. This quest for expressive nuance is responsible for endless variations in type design, including some genuine innovations, some 'new classics', and a plethora of novelty typefaces. All typefaces have personality, just like people, animals, and even architectural styles. And, just like human faces, every typeface deserves to be loved, at least once.

The link between art and typeface design is inextricable, because human mark-making is fundamental to both. Mark-making is the origin of art and the essence of communication. A study of line and shape is at the root of all typography. Weight, character and style differ in every font, and font selection can enhance, change or even undermine the meaning of the message. Type can add clarity, colour, irony, comedy or drama to the printed word, because it's not what you say, it's *how* you say it. And even those who hope to avoid such statements by choosing the likes of Helvetica have nonetheless made a very clear style statement by default.

"SOMEONE ASKED, 'DO WE NEED SO MANY TYPEFACES?' I REPLIED,
'DO WE NEED SO MANY BOOKS? DO WE NEED ANOTHER PAINTING?
DO WE NEED SO MANY SONGS? DO WE NEED ANOTHER MOVIE?'"

–Typethos, BILL DAWSON, XK9.com [1]

LOMBARDIC / UNCIALS

Blackletter/Gothic

Serif: Oldstyle

Serif: Transitional

Serif: Modern

Serif: Glyphic

Serif: Slab serif

Sans serif: Grotesque

Sans serif: Neo Grotesque

Sans serif: Geometric

Sans serif: Humanistic

Script: Formal

Script: Casual

Script: Handwriting

Script: Calligraphic

ORNAMENTAL ANTIQUES

Display fonts

digital fonts

THE FONTIGRAM

"WE ARE ALWAYS LOOKING, BUT WE NEVER REALLY SEE."

–MILTON GLASER

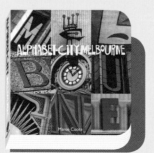

Alphabet City Melbourne, 2013 ▶

GENESIS

In 2011, while preparing the fourth edition of *The Melbourne Book: A History of Now,* and updating chapters with new photography, I noticed that among my collection of images of Melbourne buildings there lurked undeniably alphabetical shapes: a gable looking like an 'A', a double gable resembling an 'M', a column like a 'Y', and so on. I decided to create an alphabet from letter shapes hidden in the landmarks and architecture of Melbourne. So began a letter hunt, and soon I had not one Melbourne alphabet, but many, and also sets from New York and Italy.

The best Melbourne letters were collated into a chunky alphabetical primer for budding readers, aimed at encouraging 21st century children to notice the world around them. With eyes glued to screens from pram to tram, they could be missing the wonders and stimulation to be found in their own real world. They may not be triggered to question objects, events or situations; may not be inspired to ask the Why or Wherefore about a place or its history, to build their own sense of place, or even to learn basic directions. As a child I was urged to be curious, to observe consciously and deliberately: *Look up! Above the awnings! See up there? Just look at that!* I was trained in the art of actively noticing, and I hope to encourage others to look closer, to wonder and to question. Each is an important foundation skill for creativity, and the daily collection of such visual inputs is the raw material that we draw on later as designers. It becomes our internal library, an image database, the building blocks of new ideas. Pattern recognition, visual connection, lateral thinking, and fundamental curiosity are all critical to creative thinking, and all begin with being observant.

And so *Alphabet City Melbourne* was published in 2013. It soon became the theme of many school outings in Melbourne's CBD, with students seeking out the letters hidden in the archi-scape, like an urban treasure hunt.

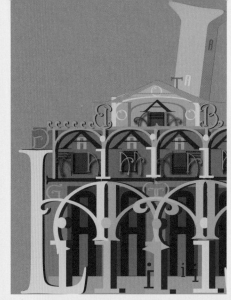

During children's workshops based on *Alphabet City*, parents often brought along toddler siblings, too young and pre-alphabet for the idea of recognising a 'Q' in a photo of a bike pedal. So I decided to create some visual aids — pictures made not with photographs, but with actual letters to help the younger ones better understand the concept: a house with an 'A' shape for its roof, and so on. But after hours puzzling letters into images, I could not escape the fact that there is no 'A' in house. I could not create confusion for children by visually connecting the wrong letter with an object, and so I began again, this time devising a set of rules to create images using only their correct spelling.

▲ *Bologna, Italia* from *Spellbound*, 2015
▼ *Snake*, exhibition poster, 2021

the rules:
Use only the *correct spelling* and only *existing* fonts. Letters can be *upside down*, *back-to-front* or *repeated* if necessary, but ideally use *no reversals* and *no repeats*.

These rules give the process both order and meaning. Using only existing fonts, and only the letters of the subject's name, an image is made through trial and retrial of typefaces, sizes, reversals, positions and combinations. The process is a kind of alphabetical sculpture — the missing link between word and image. The result is not a calligram, as it is not hand-drawn. Nor is it a pictogram. Each image is made only from existing fonts, and so I named it 'THE FONTIGRAM'.

ALPHABEASTS & ARCHITEXT

With the Letter Art device now under control, my aim was to make a connection with children about typography and observation through the use of animal subject matter (Alphabeasts). This soon extended to place-based images (Architext). The resulting books explore links between word and image, spelling and art, letterforms and illustration, learning and play. They offer a new way to notice, to spell, and perhaps open an early door to the subject of typography.

"KNOWING HOW TO LOOK IS A WAY OF INVENTING."
–SALVADOR DALÍ

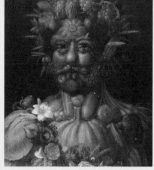

▲ Giuseppe Arcimboldo, *Vertumnus*, c.1590
▼ Wenceslas Hollar, *Landscape Shaped Like a Face*, c.1620

LETTERHEADS & LIMITATIONS

For centuries artists have puzzled with all kinds of anthropomorphic imagery by manipulating elements in the landscape, or making facial features with everything from fruit to fish. Such arcane creative adventures are as much concerned with the process as with the result, because designers love a challenge. A design puzzle with rules and restrictions is tantalising, because when design choices are limited it exercises the creative mind toward unlikely explorations and completely unexpected solutions — and toward that invisible genius, Serendipity.

Every design brief has limitations, and every medium too: photography, mosaic, collage — all are highly limited by their own innate form, yet all can yield surprising and fortuitous results. And even within the strictest creative limitations, endless permutations still seem possible. In music, just twelve notes create infinite melodies. Just five features can rearrange to express every human face in limitless individuality. And the 26 letters of the alphabet inspire innumerable typeface designs. Perhaps it is this endless possibility that draws designers to the rigours of creative constraints.

A Letter Art portrait begins with studying the face, identifying the shapes essential to both visage and personality. Then, after examining the letters available, each is assigned a font. Sometimes there are so few letters available in a name, repetition is unavoidable, but one glyph per letter remains the ideal. Finding fonts to match both physical and emotional dimensions as well as graphic appeal is a process that regularly involves serendipity — when a letter just demands to become a particular feature. After achieving a likeness, the aim is to then continue a process of simplification, and venture beyond into caricature and abstraction. Ultimately, the aim is not to simply spend letters until an image is forced into being, but to look for the art, for the economy, for the poetry: for the most simpatico marriage of word and image.

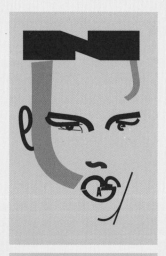

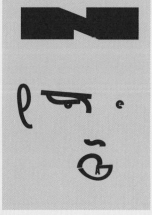

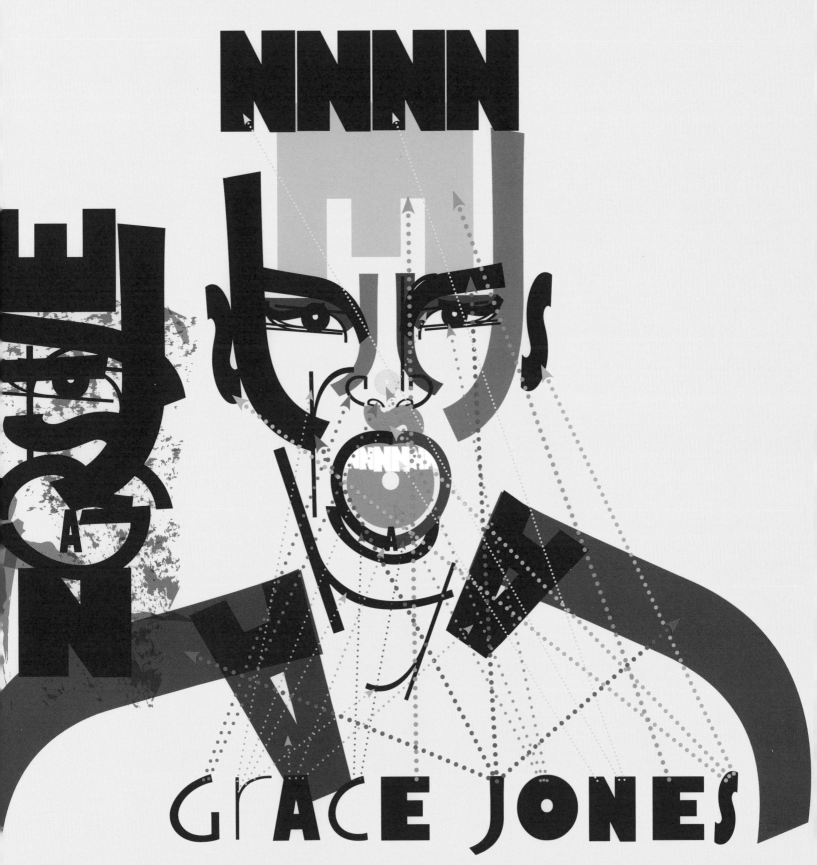

GRACE JONES

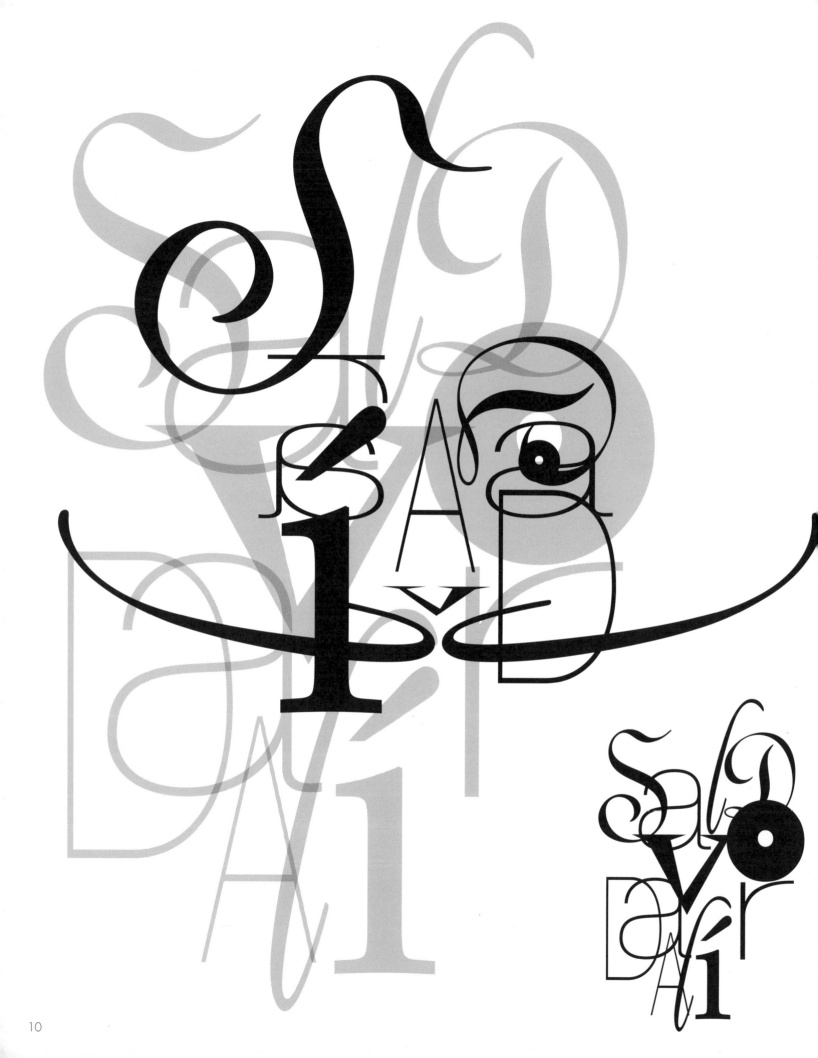

"INVITE THE READER TO PARTICIPATE IN THE DECIPHERING. CHAOS CAN ATTRACT AND ENGAGE."

–DAVID CARSON, designer/typographer

GOTHIC ORIGINS

The ancient Germanic Goths were comprised primarily of the Visigoths (of the west) and Ostrogoths (of the east). Reviled as the barbarians who overthrew the Romans in 497 AD, they were linked to the subsequent Dark Ages, and perhaps this is where the 'dark' association begins. Having already made their mark with the invention of the Gothic alphabet and the Gothic Bible (4th century), the Goths gave much to history. During the Middle Ages in Europe (400s–1400s AD), they linked their brand name to state-of-the-art cathedral architecture by way of technological genius-moves like the soaring pointed Gothic arch, the barrel vault and the flying buttress, all of which revolutionised religion in the mid 12th century. Bible production flourished using the hand script text or 'textura' of the day, known as Gothic or blackletter. By the time the Renaissance arrived in the 1400s with its shiny new science, and enlightened ideas, Gothic-ness became automatically linked with The Past, and therefore to all things dark, malformed and backward. The adjective 'Gothic', used as a pejorative term meaning 'barbaric', was attached to all such medieval icons, including blackletter script.

▲ The Gothic Alphabet devised in the 4th century, seen here in the *Codex Argenteus*, a 6th century Gothic Bible manuscript

▲ Textura script, also known as Gothic or blackletter script, in use from the 12th to the 17th century

Gothic script and Gothic ideas in architecture, literature and film have nevertheless been kept alive by generations who continue to breathe new life into a culture of the Gothic. Distilled into its extremes, it is expressed as a world of cloistered perversion, deformity, dark ritual and aberration. Best illustrated by monsters and melodrama, the Gothic simply won't stay dead. According to type designer Nick Shinn, the likes of Punk, Halloween, Batman comics, Walt Disney, Game design and so on, ensure 'the undead is no less significant than the living' and 'the Gothic is on a roll' today.[2]

Perhaps the ideal personification of the Gothic is Mary Shelley's novel *Frankenstein*, written in 1818. In this Letter Art portrait (opposite), Shelley's creation is assembled using his master's name in a monster-mash of alphabets including a Gothic blackletter 'e' and 'i' (*Font: Fette Fraktur*), a kooky, unsettled serif 'N' and 'f' (*Font: Fontesque Bold/Extra Bold*), a crypt-appropriate script 'A' (*Font: Herculaneum*), and two so-called 'grotesque' sans serif fonts (*Fonts: Futura; Helvetica*).

abcdefghijklmnopqrstuvwxyz
Fette Fraktur

"IN TODAY'S DUMBED-DOWN, TABLOID-DRIVEN CULTURE, THE GOTHIC IS ON A ROLL."

–NICK SHINN, type designer

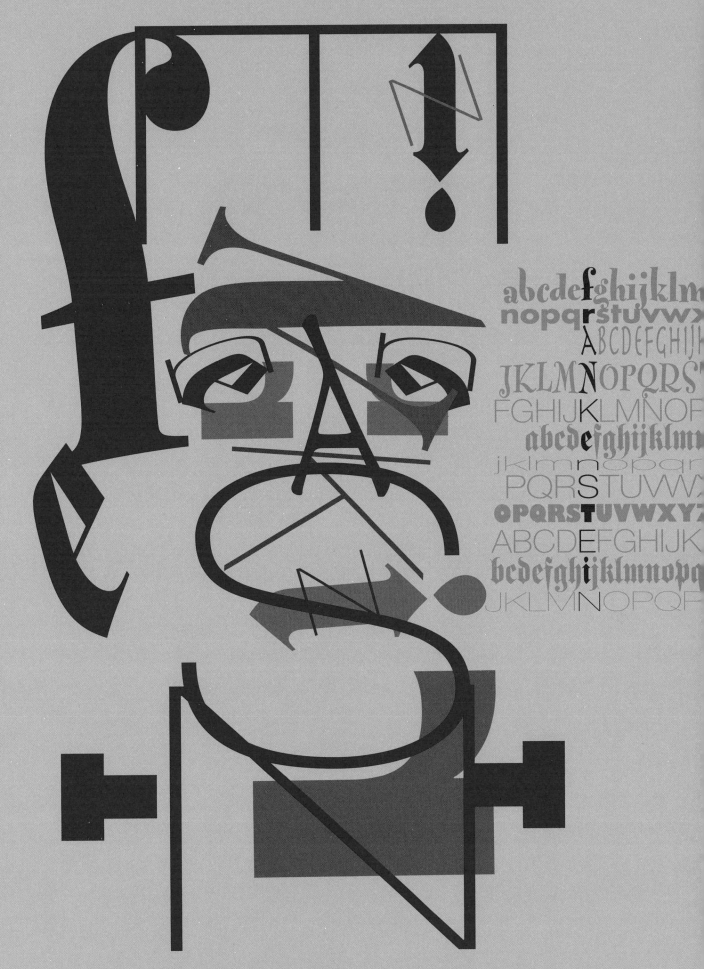

abcdefghijklm
nopqrstuvwx
ABCDEFGHIJK
JKLMNOPQRS
FGHIJKLMNOP
abcdefghijklm
jklmnopqr
PQRSTUVW
OPQRSTUVWXYZ
ABCDEFGHIJK
bcdefghijklmnopq
JKLMNOPQR

GOTHIC BLACKLETTER

This hero of Bram Stoker's 1897 Gothic masterpiece *Dracula* reveals a spooky collaboration between two classic Gothic blackletter scripts. A deranged gaze includes lowercase letters 'd' (*Font: Fette Fraktur*) and 'l' (*Font: Cloister*), and a cloak is tied with a blackletter capital 'R' (*Font: Cloister*).

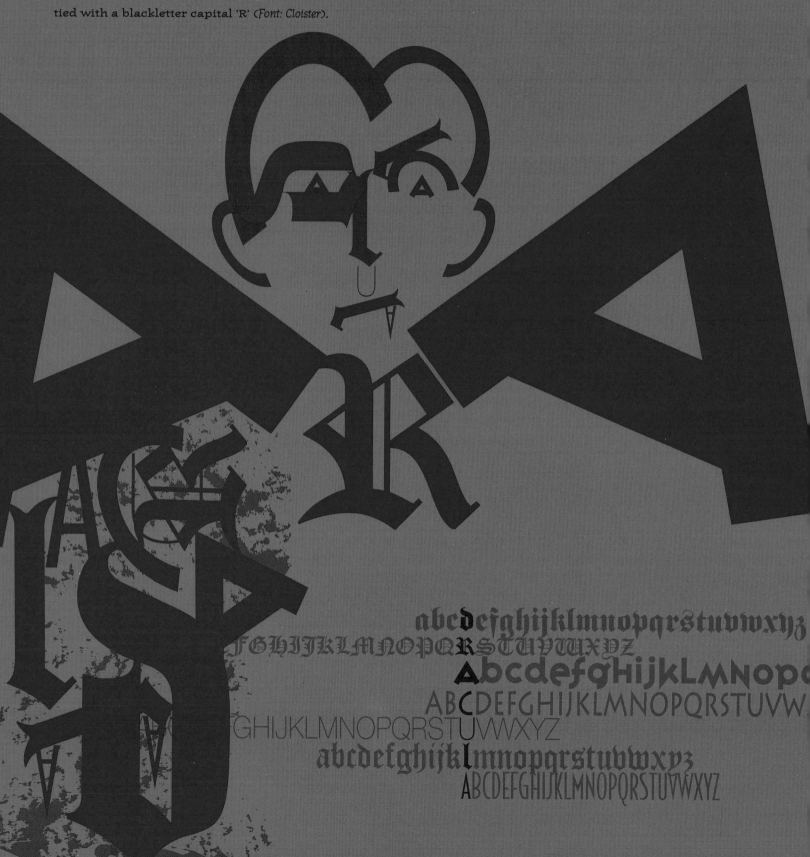

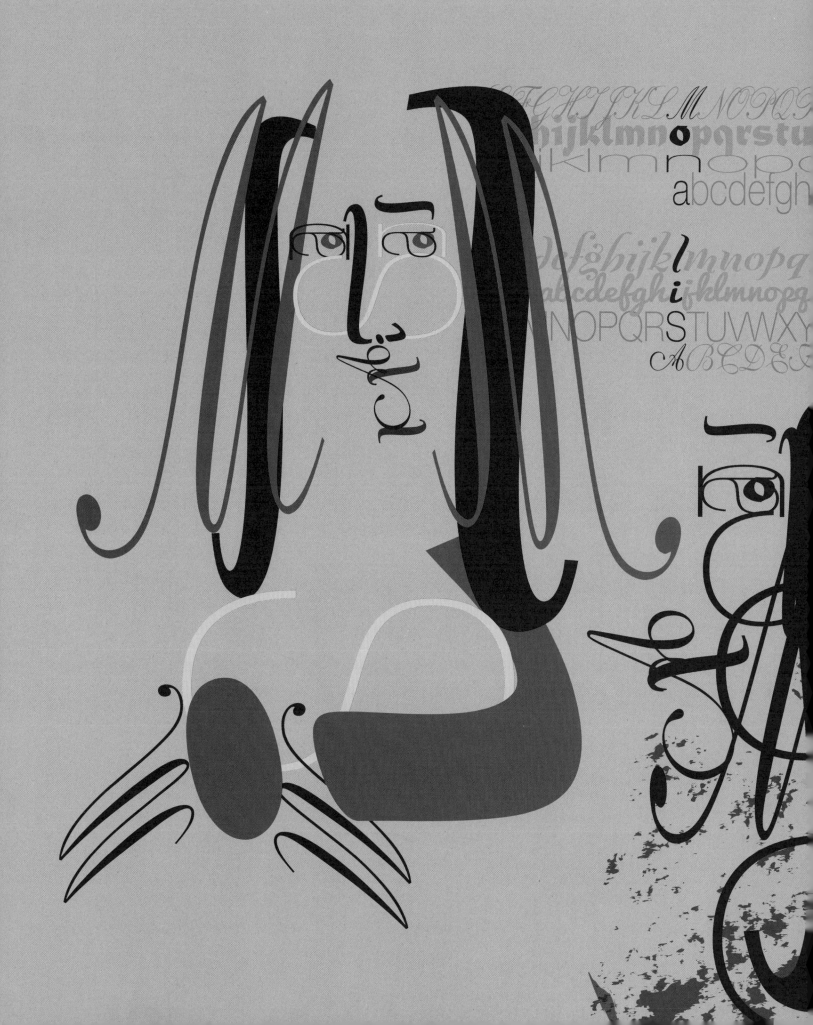

UNCIALS & HISTORIATED INITIALS

Uncial letterforms were used to mark chapters and enhance the pages of medieval religious manuscripts. Often these were further 'historiated' and filled with splendid narrative illustration. Recognised by their distinctive rounded forms, uncials are known as 'majiscule' scripts (capital letters only), and are the ancestors of today's uppercase. 'Minuscule' or small letters combine with capitals to create 'bicameral' or dual case scripts.

Modern fonts inspired by such medieval uncials create this regal costume in letters 'Q' and 'E' (*Font: Studz*), and make the Queen's hairstyle and Shakespeare's ruff (opposite) with Lombardic capitals 'E', 'N', 'B' and 'S' (*Font: Goudy Text Lombardic Capitals*).

GOUDY TEXT LOMBARDIC

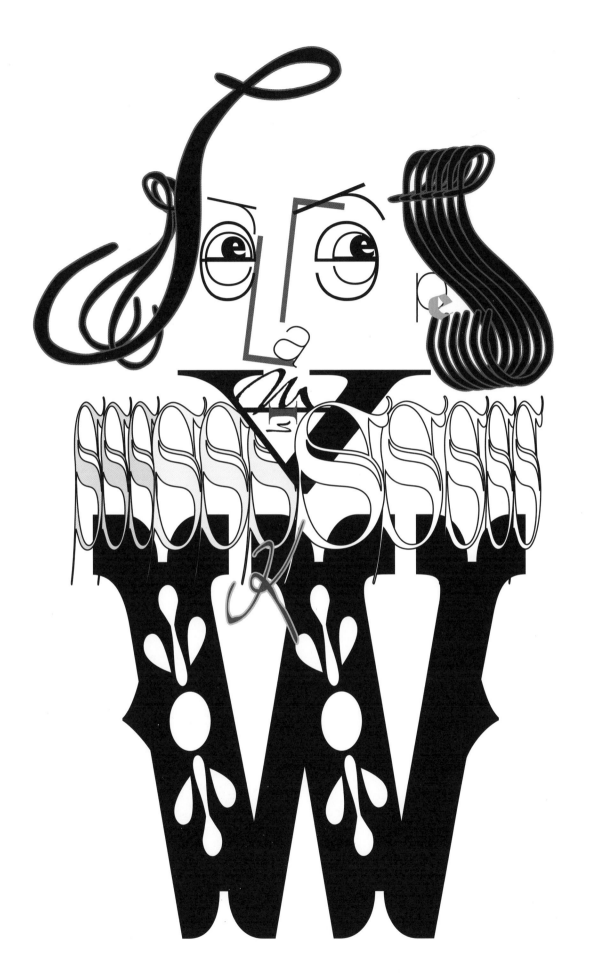

WILLIAM Shakespeare

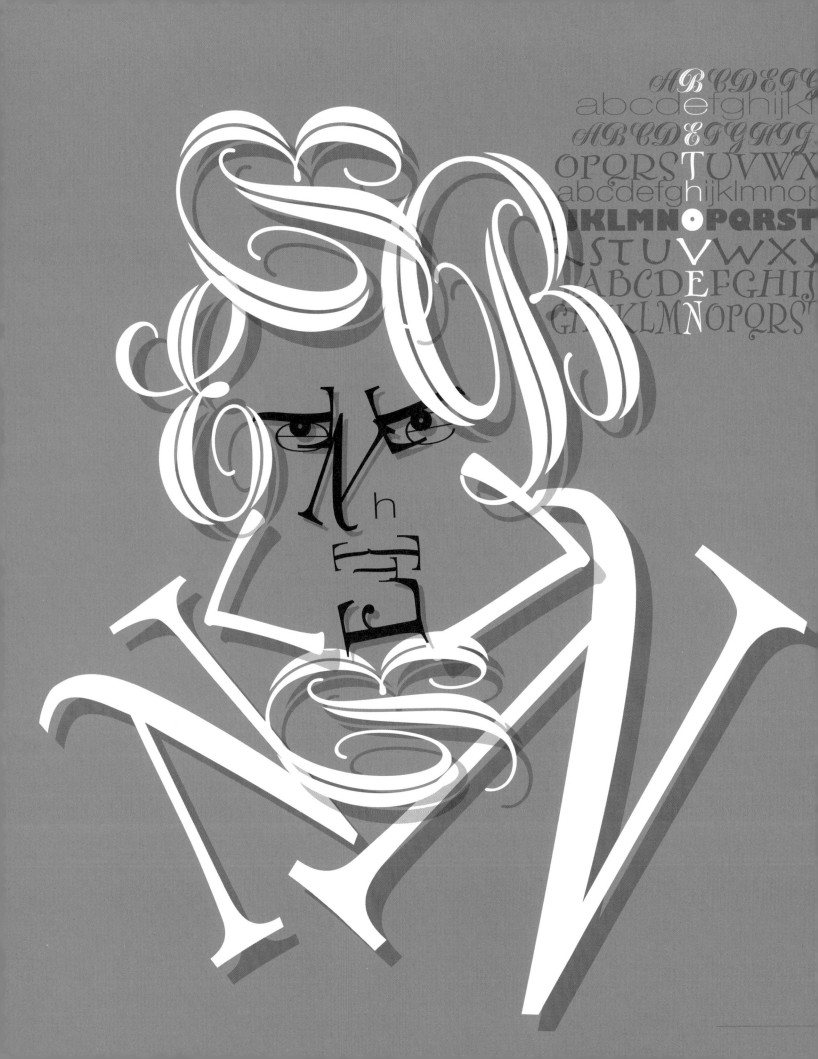

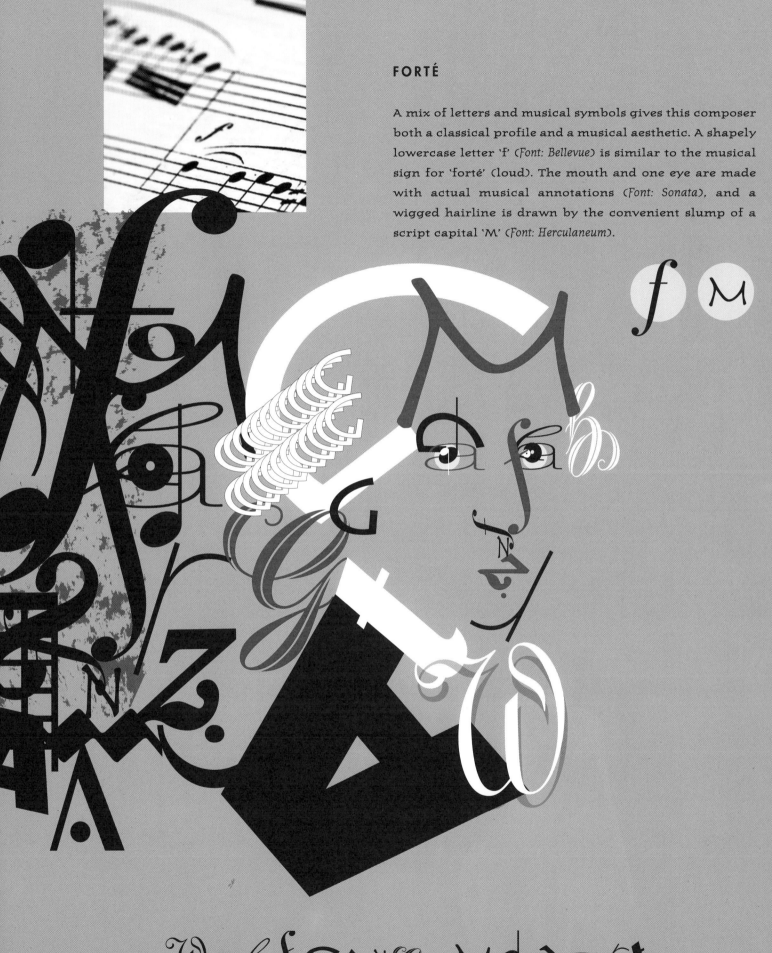

FORTÉ

A mix of letters and musical symbols gives this composer both a classical profile and a musical aesthetic. A shapely lowercase letter 'f' (*Font: Bellevue*) is similar to the musical sign for 'forté' (loud). The mouth and one eye are made with actual musical annotations (*Font: Sonata*), and a wigged hairline is drawn by the convenient slump of a script capital 'M' (*Font: Herculaneum*).

Wolfgang Mozart

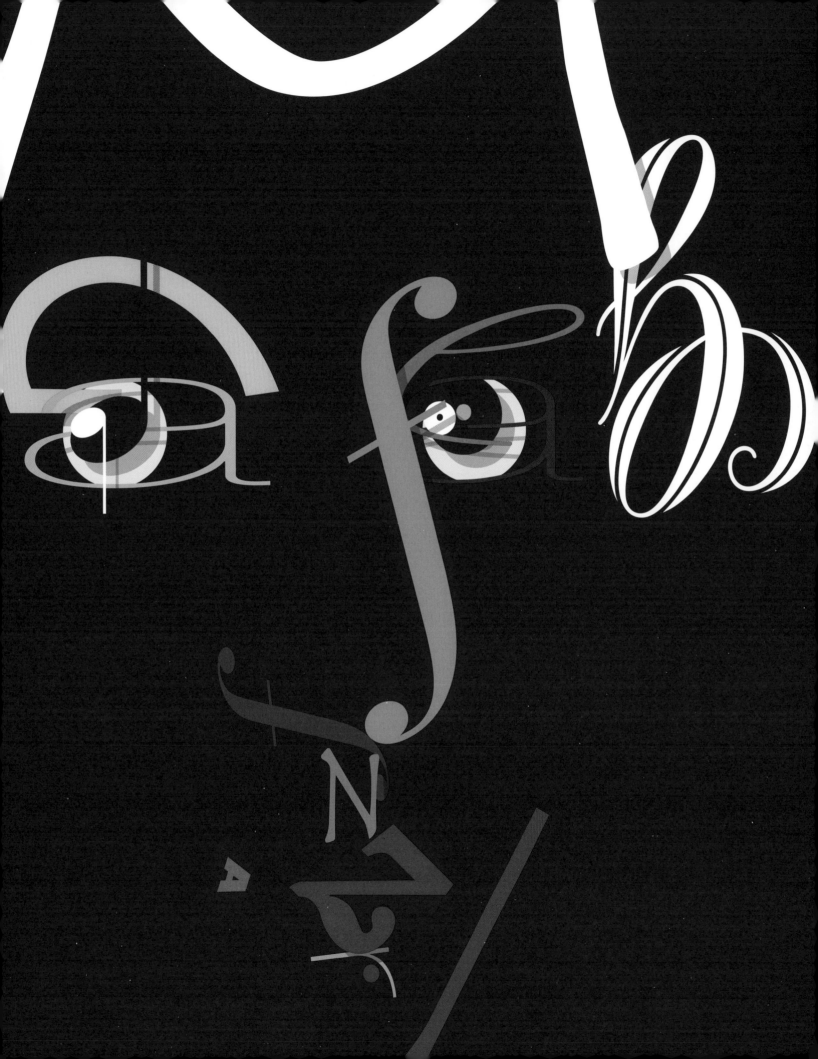

▲ Blackletter calligraphy

▲ Blackletter letterpress metal type slugs

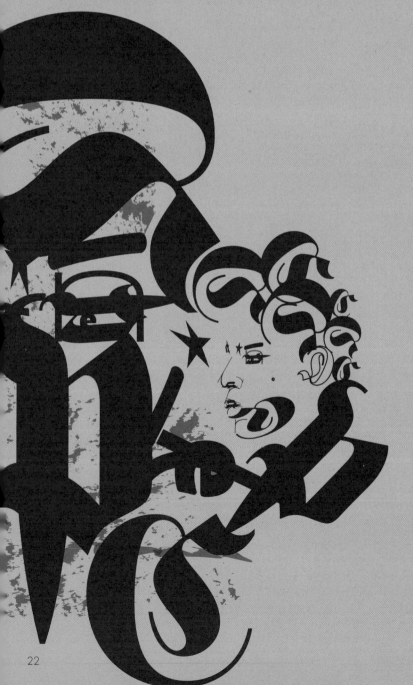

GOTHIC FUNK

Gothic blackletter typefaces were created to imitate the pen strokes of medieval calligraphy — the heavy downstrokes and fine drag lines created by a nib as it marks, lifts and marks again. To the modern eye, blackletter is tortuous to read: its capitals indecipherable, its lowercase stern and self-righteous. But in its day, monastic scribes, court officials and readers of religious texts were very accustomed to this style of letter, and to them it was highly legible. So it was logical to recreate these familiar, handmade letterforms as machine fonts when European letterpress printing was first invented in 1450.[3] Blackletter eventually began its decline around the 16th century as the Roman letter style became increasingly popular.

In this portrait (opposite), serendipity transforms Gothic severity into high camp via a blackletter lowercase 'p' and capital 'C' (*Font: Fette Fraktur*). A novelty font supplies an unorthodox lowercase 'i' (*Font: Giddyup Regular*) to add the requisite touch of glitz. Rearranging the same five letters also yields a profile version, left.

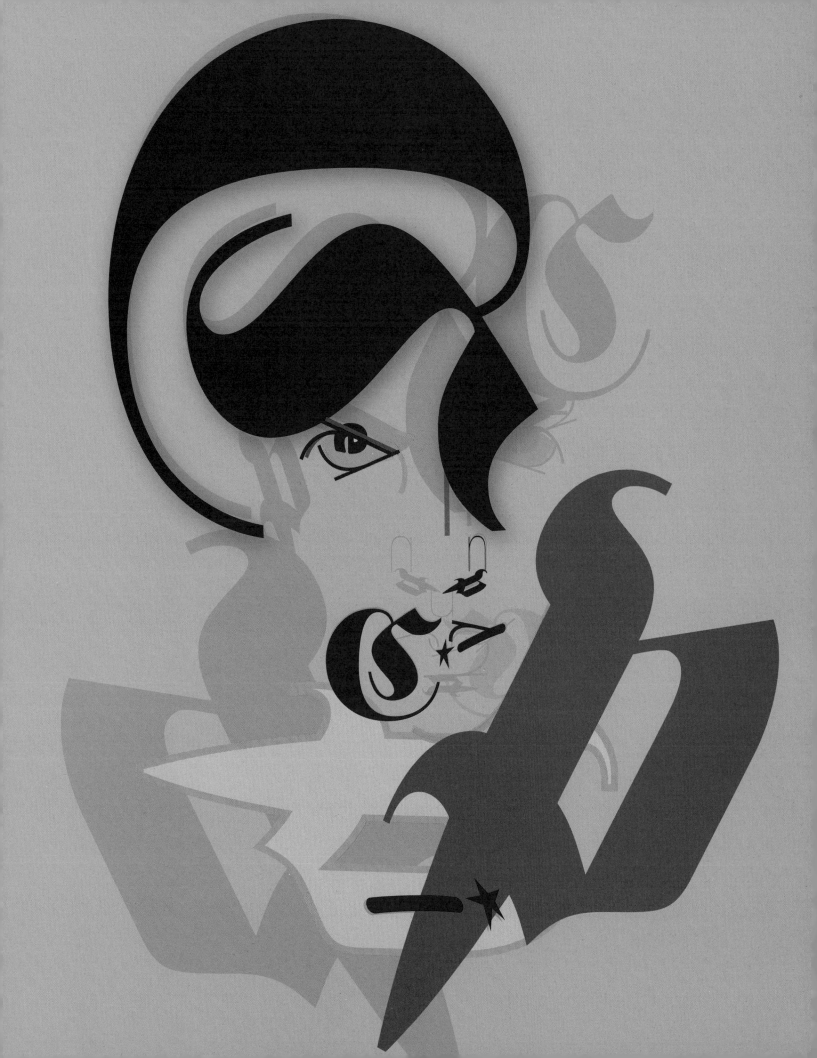

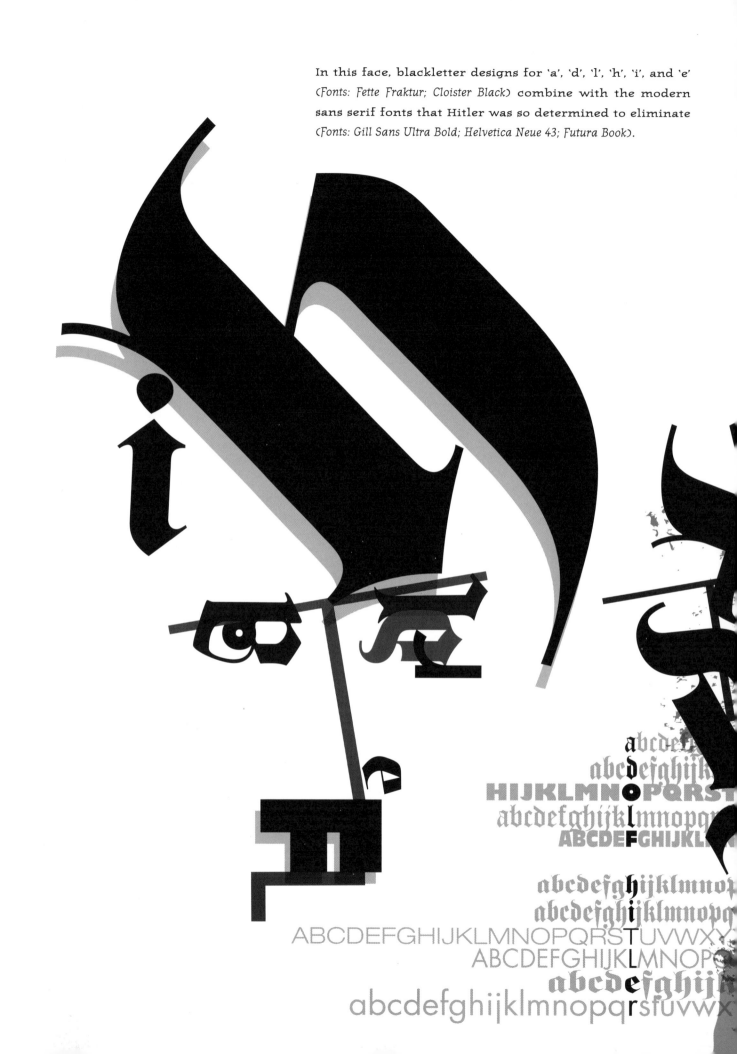

In this face, blackletter designs for 'a', 'd', 'l', 'h', 'i', and 'e'
(Fonts: Fette Fraktur; Cloister Black) combine with the modern
sans serif fonts that Hitler was so determined to eliminate
(Fonts: Gill Sans Ultra Bold; Helvetica Neue 43; Futura Book).

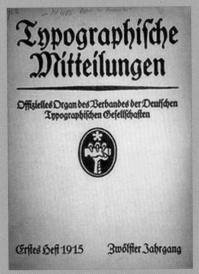

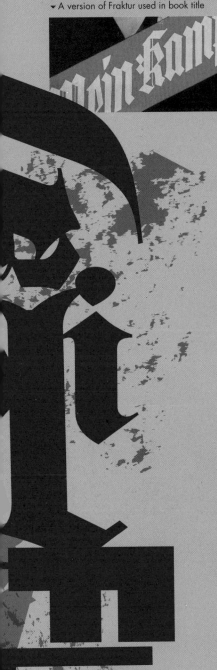

▲ *Typographic Messages: The Official Organ of the Association of German Typesetting Companies*
▼ *A version of Fraktur used in book title*

GOTHIC POLITIC

After WW1 in Germany (the home of blackletter), Gothic typefaces were proudly claimed as the traditional German form. At a time of rising nationalism, Gothic text was a nostalgic favourite that belonged to the very roots of Western typography and printing itself, and had become synonymous with German national pride and identity. In the lead up to WW2, Germanic styles in art and design were strictly directed by authorities via the *Bund Heimatschutz*, a kind of cultural protectorate. So while the Modernists of the 1920s Bauhaus design movement ventured away from Gothic fonts to Roman letterforms and beyond to exciting new sans serif typefaces like Universal and Futura, German authorities insisted that only blackletter could reflect the nation's purity.

Paul Renner, who designed Futura in 1928, stridently questioned the state's interference in culture and design, saying: 'Political idiocy, growing more violent and malicious everyday, may eventually sweep the whole of Western culture to the ground with its muddy sleeve'.[4] Futura was immediately labelled by the authorities as 'anti-German'[5] and Renner was arrested by the Nazis in 1933 for his modernist strivances, and forced to resign his teaching position due to his subversive typography and 'national untrustworthiness'.[6] Meanwhile, Fette Fraktur (which translates as 'fat fracture' and was nicknamed the 'jack boot Gothic'), was installed as the official font of the Reich. The cover of Hitler's biography *Mein Kampf* used a hand-drawn version of Fraktur.

Fette Fraktur
Antiqua
Futura

Ultimately, pragmatism favoured good design. Realising blackletter was virtually illegible to many and difficult to implement on foreign presses, it became a barrier to propaganda and the Nazi machine relented. Fraktur was banned in 1941 and replaced with Antiqua, a Roman serif style, before the futuristic sans serif Futura was finally claimed as the preferred official style. In a breathtaking authoritarian backflip, Renner's Futura was even included in the official Nazi typesetting handbook.[7]

GOTHIC SHOCK

Today, blackletter remains a font favourite for newspaper mastheads and beer labels, but it still has the power to shock. Confronting and aggressive, Gothic gets noticed. It has retained its controversial appeal for goths, punks, neo-Nazis, heavy metal and shock-rockers, motorcycle clubs and tattoo parlours. In this portrait, a Gothic 'i', 'e' and 'p' (Font: Fette Fraktur) combine with an inverted 'A' (Font: Herculaneum) and capital 'C's (Fonts: Calavera One; Gill Sans Ultra Bold) to give this face just the right affectation of threat.

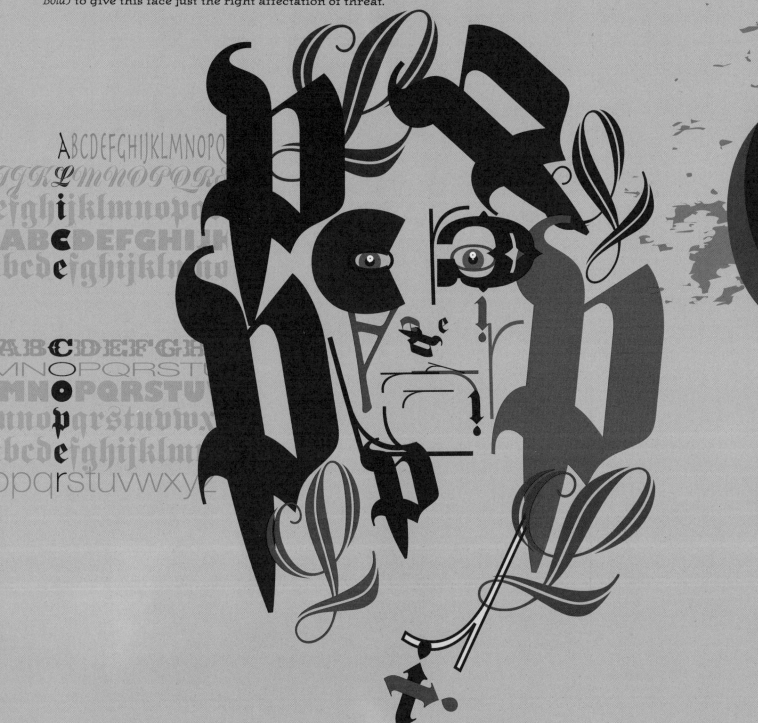

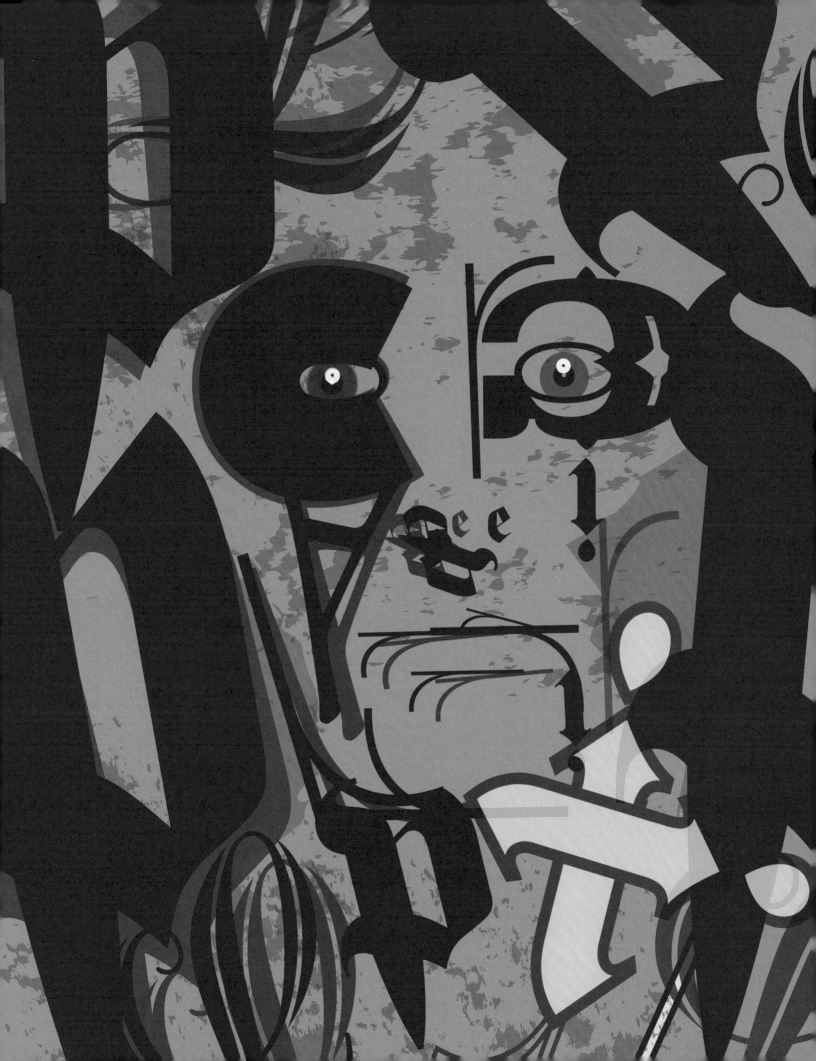

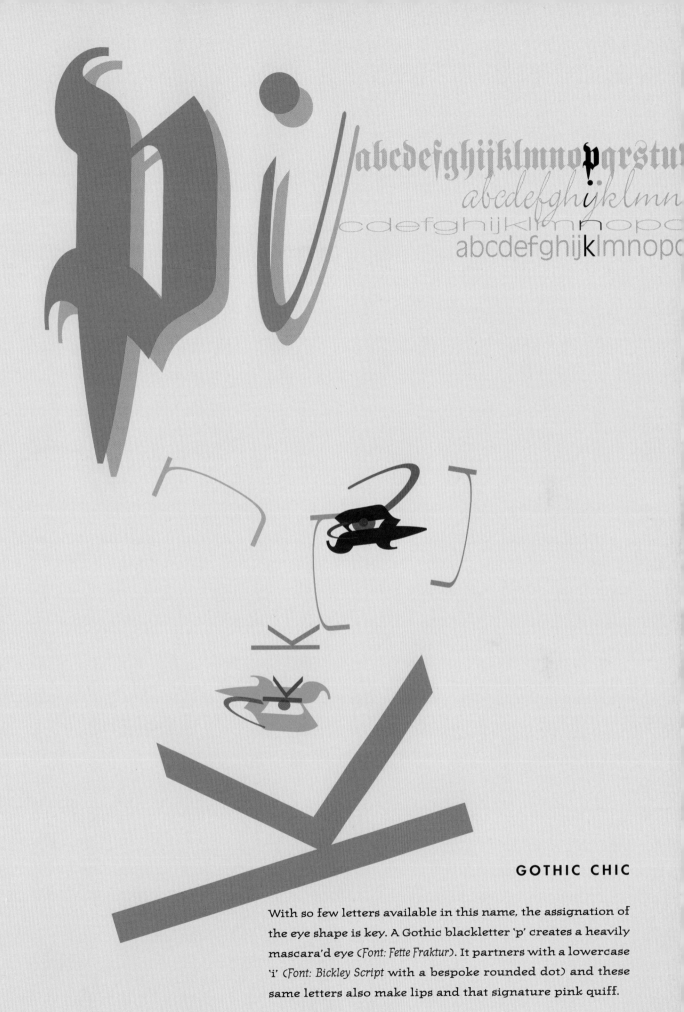

GOTHIC CHIC

With so few letters available in this name, the assignation of the eye shape is key. A Gothic blackletter 'p' creates a heavily mascara'd eye (*Font: Fette Fraktur*). It partners with a lowercase 'i' (*Font: Bickley Script* with a bespoke rounded dot) and these same letters also make lips and that signature pink quiff.

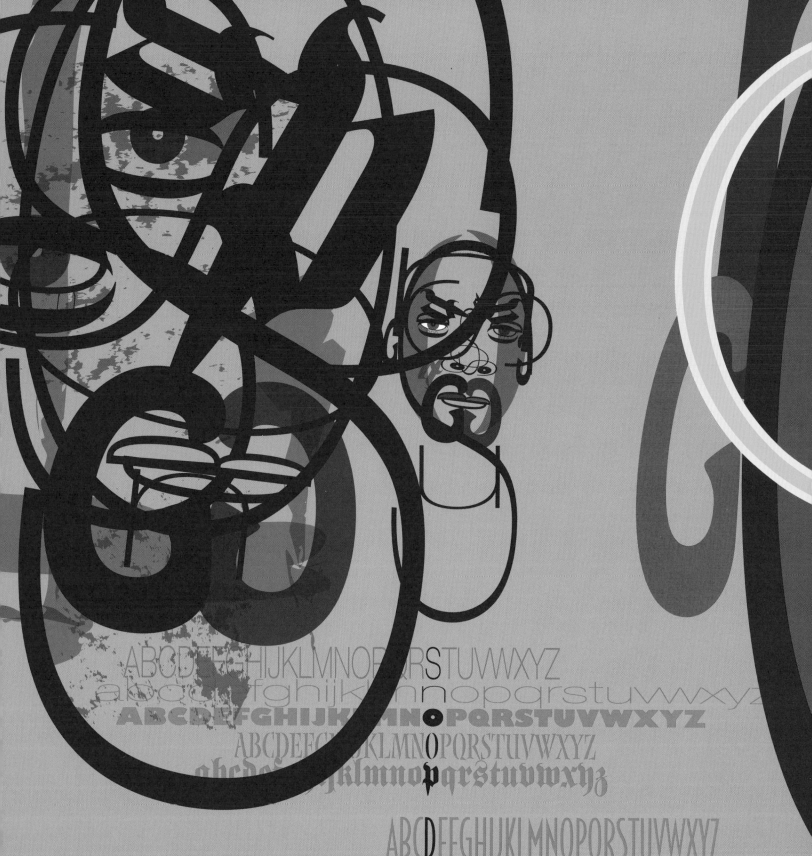

ABCDEFGHIJKLMNOPQRSTUVWXYZ
abcdefghijklmnopqrstuvwxyz
ABCDEFGHIJKLMNOPQRSTUVWXYZ
ABCDEFGHIJKLMNOPQRSTUVWXYZ
abcdefghijklmnopqrstuvwxyz

ABCDEFGHIJKLMNOPQRSTUVWXYZ
ABCDEFGHIJKLMNOPQRSTUVWXYZ
ABCDEFGHIJKLMNOPQRSTUVWXYZ
ABCDEFGHIJKLMNOPQRSTUVWXYZ

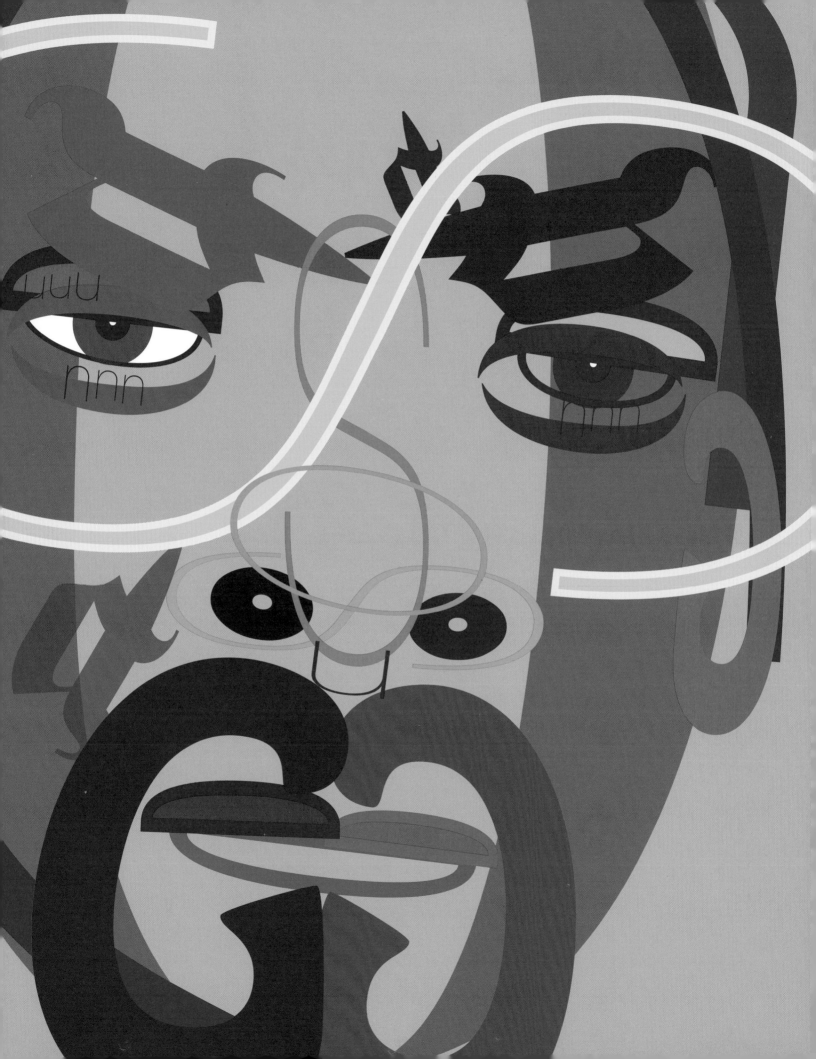

ABCDEFGHIJKLMNOP

defghijklmnopqr

bcdefghijkl

pqrstuvw

C

SLEEK

A slim Deco-style capital 'C' makes brows, eyes and nose, and is condensed a little for long, straight hippie tresses (*Font: Bodega Sans*).

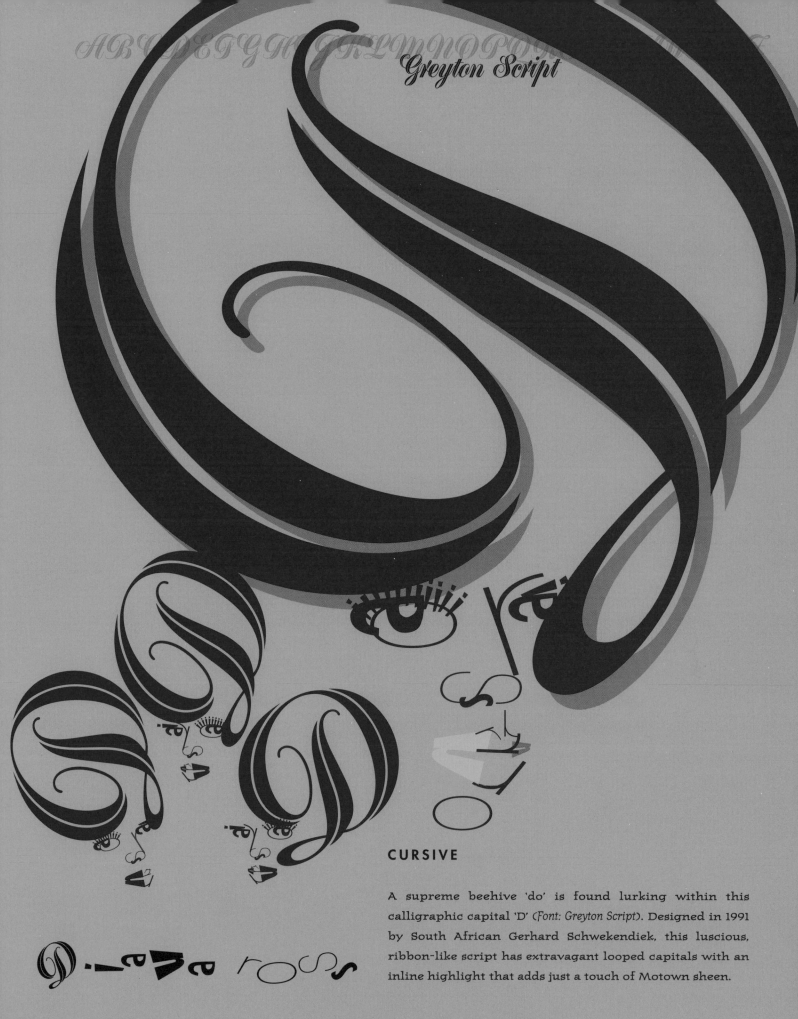

CURSIVE

A supreme beehive 'do' is found lurking within this calligraphic capital 'D' (*Font: Greyton Script*). Designed in 1991 by South African Gerhard Schwekendiek, this luscious, ribbon-like script has extravagant looped capitals with an inline highlight that adds just a touch of Motown sheen.

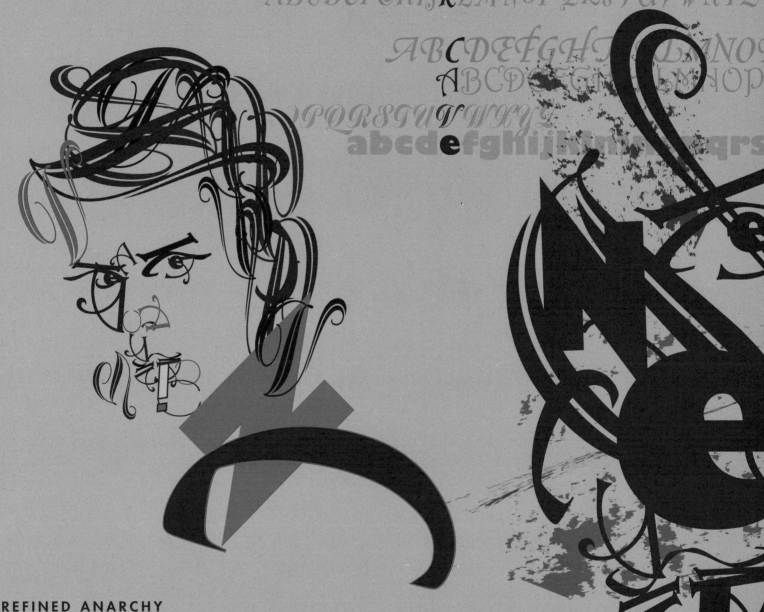

REFINED ANARCHY

The capital 'A' that so conveniently forms eye, cheek, nose and bottom lip comes from an alphabet based on the decadent, high-waisted Art Nouveau fonts of the late 19th century (Font: Hermosa). Elegant and evocative, these letters were often adorned with florid swashes or tendrils, contrived to echo the organic shapes of nature at the centre of Art Nouveau.

ABCDEFGHIJKLMNOPQRSTUVWXYZ

HERMOSA

ABCDEFGHIJKLMNOPQRSTUVWXYZ
IJKLMNOPQRSTUVWXYZ
TUVWXYZ

STUVWXYZ
ABCDEFGHIJKLMNOPQRSTUVWXYZ
jklmnopqrstuvwxyz
abcdefghijklmnopqrstuvwxyz
bcdefghijklmnopqrstuvwxyz
KLMNOPQRSTUVWXYZ
klmnopqrstuvwxyz
NOPQRSTUVWXYZ
abcdefghijklmnopqrstuvwxyz

RELAXED ECCENTRICS

Of all the script styles, 'casual' scripts are the least formal, characterised by relaxed, handmade shapes. Here they add eyeliner via a capital 'A' (*Font: Freestyle Script Bold*), make both shoulder strap and ponytail with an 'h' (*Font: Brush Script*), and tease up into a beehive, courtesy of a capital 'W' tipped on its side (*Font: Brush Script*). For a more economical Fontigram, the close-up version opposite uses a sans serif 'h' for the bottom lip (*Font: Helvetica Neue 25*).

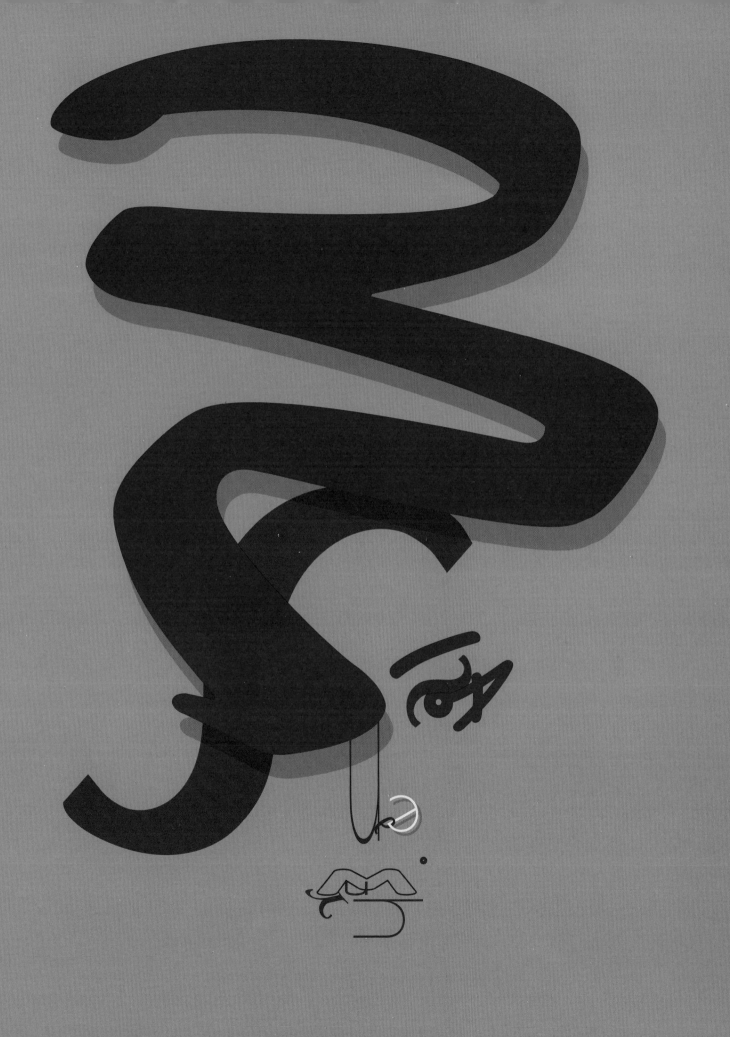

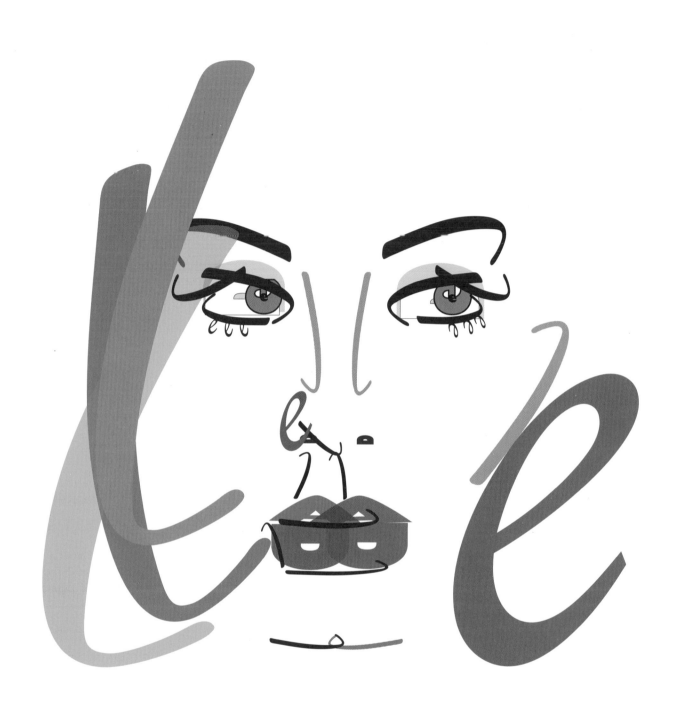

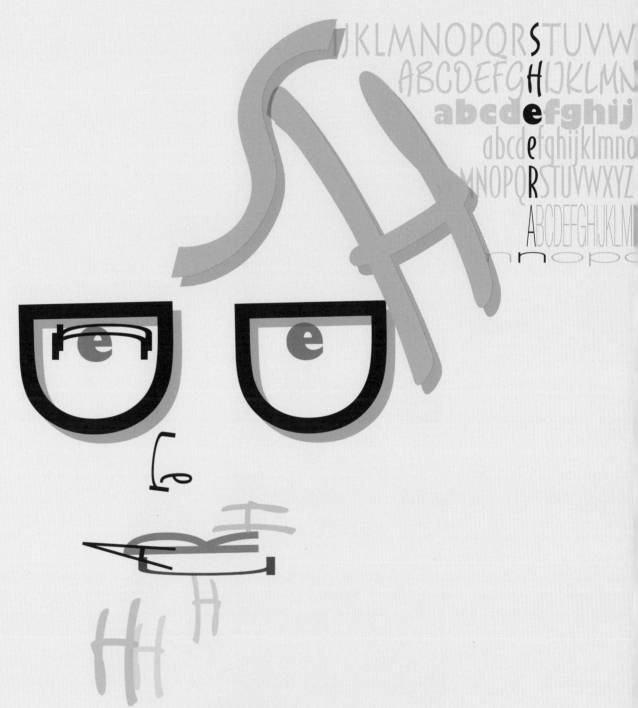

CONTRAST

An open, stylish capital 'D' frames this face (*Font: Century Gothic*), but it's the low-contrast colouration of a fair complexion that is the key feature of this portrait. A relaxed capital 'H' draws loose strokes for hair and beard, and comes from a beautifully balanced script designed by Alan Meeks (*Font: Limehouse Script*).

Limehouse Script

PARAPHERNALIA

In the 1960s, Peace and Love pacified all, including military regalia. Here, an 'N' makes an ornate high-collared army jacket (Font: Calavera Two), with rows of 'i's as regimental buttoning (Font: Freehand 521), all disarmed by the beauty of the subject and the paraphernalia of bohemia: a bandana 'J' (Font: Flo Motion), a moustache 'r' and scarf 'i' (Font: Klunder Script).

BCDEFGHIJKLMNOPQRSTUVWXYZ
abcdefghijklmnopqrstuvwxyz
HIJKLMNOPQRSTUVWXYZ
ABCDEFGHIJKLMNOPQRSTUVWXYZ

bcdefghijklmnopqrstuvwxyz
abcdefghijklmnopqrstuvwxyz
HIJKLMNOPQRSTUVWXYZ
ABCDEFGHIJKLMNOPQRSTUVWXYZ
jklMNOPQRSTUVWXYZ
abcdefghijklmnopqrstuvwxyz
QRSTUVWXYZ

TUSCAN & ORNAMENTAL ANTIQUES

Originating in Rome in early Christian inscriptions, ornamental typefaces are decorative and intricate. They were revived in the 19th century at the time of the Industrial Revolution, and soon spread from English and French type foundries to the Americas.

The advent of Freidrich Koenig's steam-powered printing press in 1814 saw the cost of printing fall, enabling an explosion of handbills, pamphlets, newspapers, posters and signs. Ornamental display fonts became extremely popular in these publications, helping to categorise information by aiding type hierarchy and separating ideas, especially in newspapers and almanacs. They also supplied both prestige and brand identity at a time before printed illustrations and logos were common. Decorative and bespoke, the prime role of such display typefaces was to please the eye and attract attention to advertising messages, and type foundries developed a huge variety of these designs.

The most eccentric of these ornamentals are known as 'Tuscan' antiques, characterised by either bifurcated or trifurcated (branched) serifs, (reminiscent of a three-leafed lilium from Tuscany that gives them their name). They have a decorative outline, often paired with medial ornamentation like bumps or spurs half-way down the letter stem. Further enhanced with tone, pattern, dimension, colour and flourish, they proliferated in exquisite variety. Highly popular with the general public and used extensively in vernacular publications, these typefaces became synonymous with America's two exciting new frontiers: the Wild West, and Advertising.

CALAVERA 2

Designed in 2012 by Mexican designer Oscar Yáñez, Calavera is influenced by these Tuscan fonts, and named for 19th century Mexican engraver, Manuel Manilla, famous for his caricatures of the figure of Death in the form of 'calavera' (skulls and skeletons), still popular in *Dia de los Muertos* celebrations today. A font family of seven designs with embellishments inspired by Mexican folk art paper-cutting, Calavera is both extravagant and disciplined, making it a soul-match for this portrait.

AVANT GARDE

The artist as a work of art: Warhol's eccentric thatch of hair can be drawn by a tilted bold sans serif 'W', below (*Font: Avant Garde Bold Italic*), or a messier script capital 'W', (*Font: Tiger Rag Plain*).

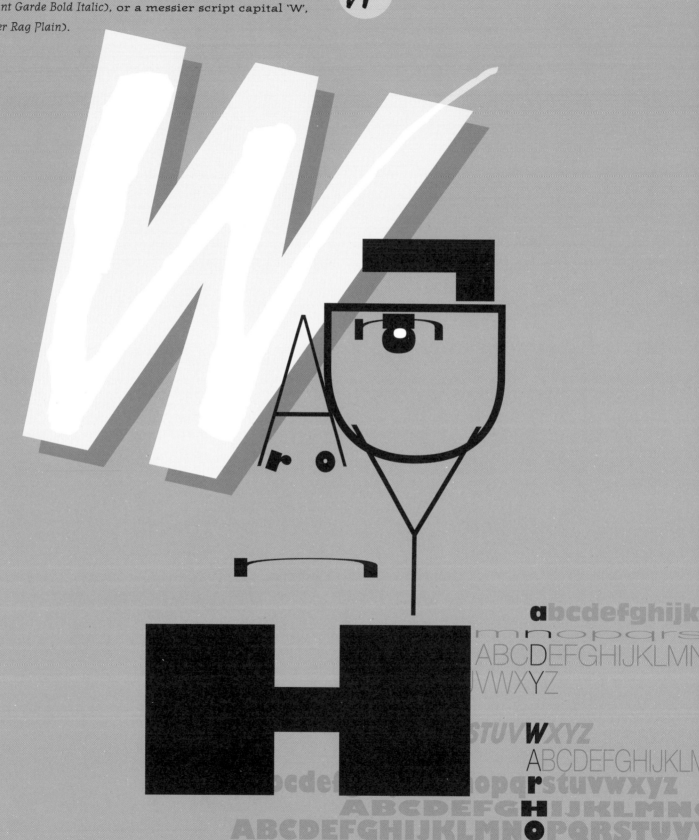

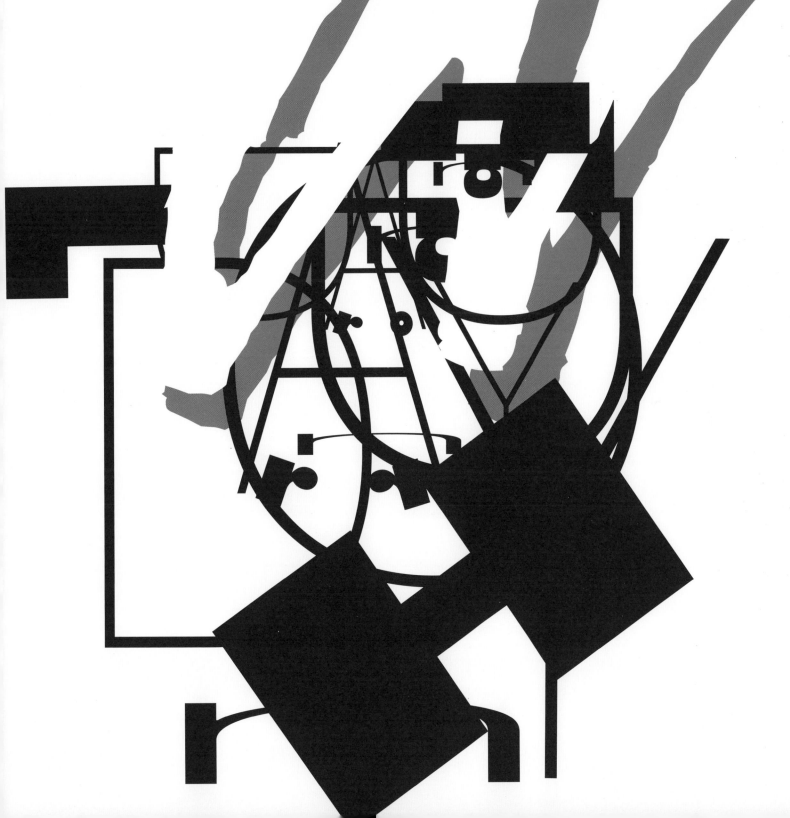

SURREAL

Dalí's crazed stare is spelled here by the combination of a lowercase 'a' (Font: Helvetica Neue 25), a capital 'O' (Font: Gill Sans Ultra Bold), and a capital 'D' (Font: Linoscript), and his famous moustache is drawn with a sweeping script lowercase 'l' (Font: Sloop Two). Opposite, an upturned 'U' frames Yayoi Kusama's striking red bob (Font: Hobo).

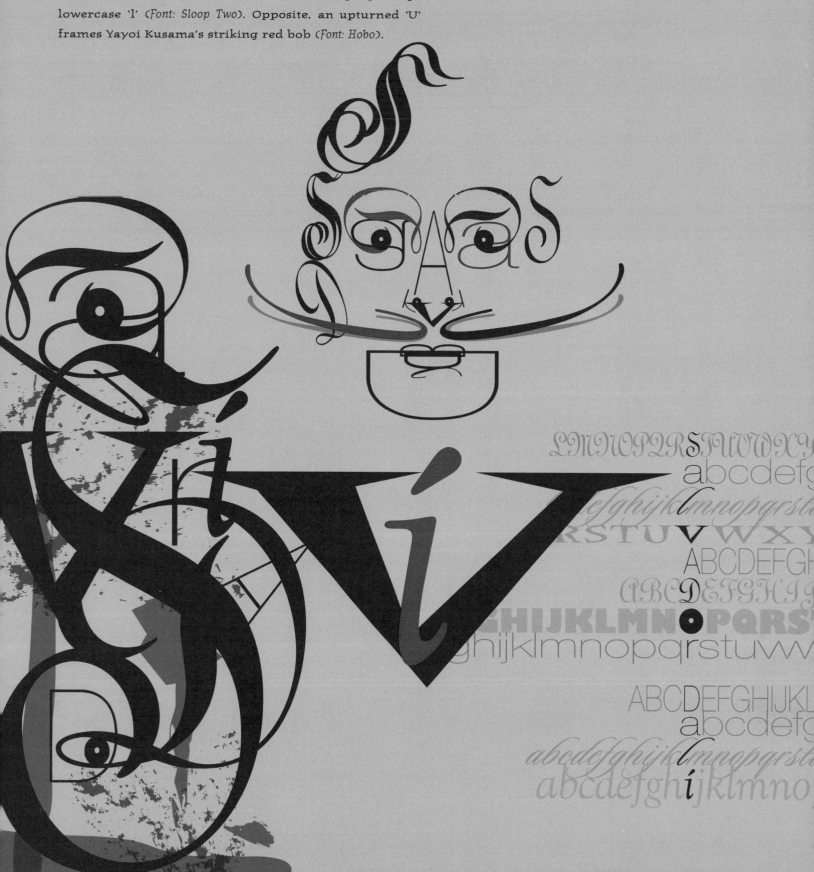

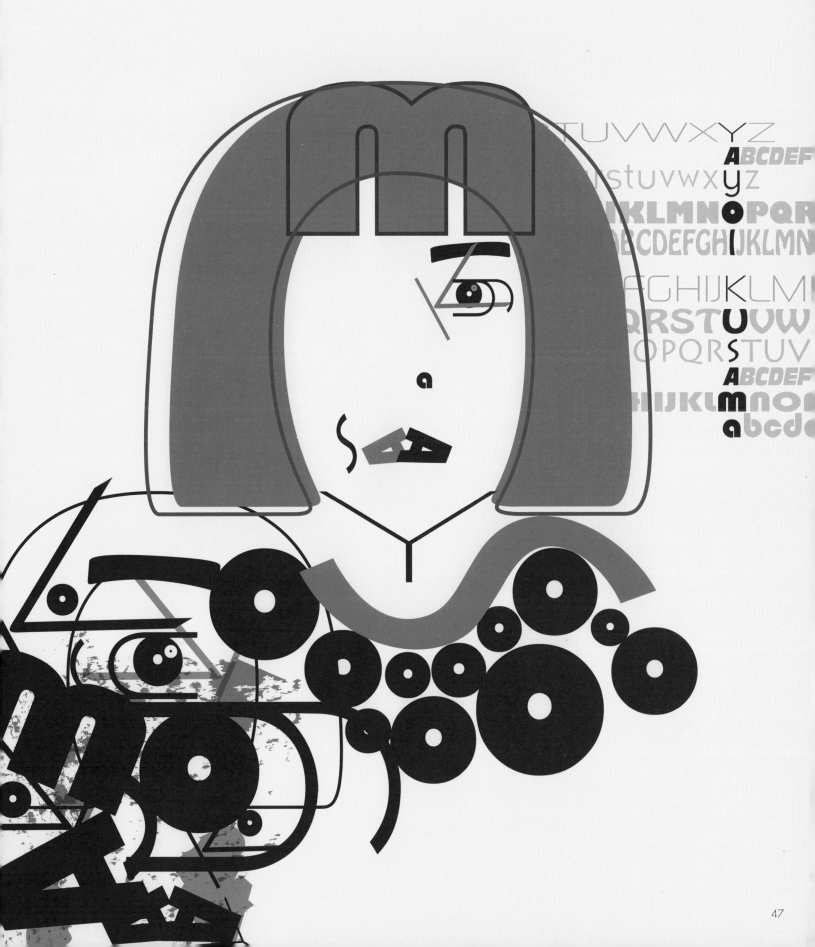

TUVWXYZ
rstuvwxyz
IJKLMNOPQR
BCDEFGHIJKLMN
FGHIJKLMN
QRSTUVW
OPQRSTUV
ABCDEF
HIJKLMNO
abcde

A
y
o
i
U
s
A
m
a

47

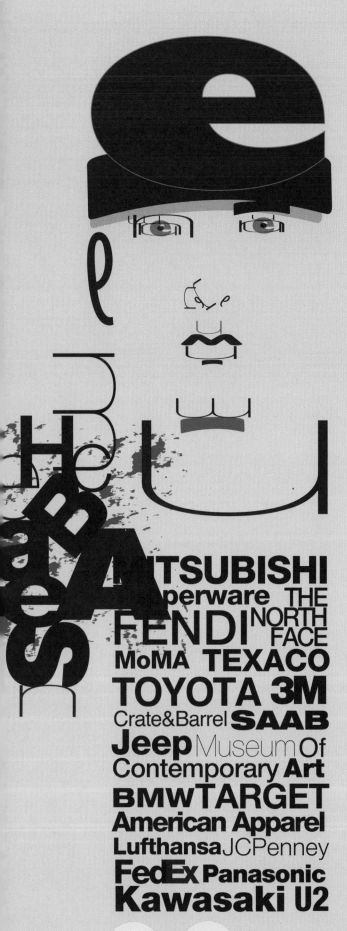

HELVETICA

Sans serif fonts are the ideal match for this no-nonsense persona, and in this portrait an extended lowercase 'n' defines most of the facial lines (*Font: Helvetica Neue 25*).

Created in 1957 by Swiss type designer Max Miedinger, Helvetica was originally called 'Neue Haas Grotesk', but was renamed after the Latin word for 'Swiss', synonymous with ultra-modern mid-century design. It was intended to be the ultimate type solution and soon became the most popular typeface of the 20th century. With its sans serif modernity and tall, open x-height, it offered great readability and neutrality. It did not colour the message, and so could be used for a wide variety of purposes. Helvetica became the default choice for transport way-finding on road signs, rail systems and airports all over the world. This combination of neutrality and clarity meant Helvetica was the easy design decision for brand marketers hoping to achieve mass appeal. It has been used in the logotypes of many hundreds of corporations as diverse as Jeep and the Museum of Contemporary Art, Canada.

However, by the 1970s, there was a reaction against the conformity of Helvetica. It was everywhere. It was boring. It was so ubiquitous it had become invisible. Type designers abandoned clarity and utility. They turned toward more playful, expressive, post-hippie explorations of illustrative typography. Politics and expressionism raged through graphics, and by the 1980s, the Punk rebellion had manifested itself in the style zeitgeist as Grunge, smashing the last of those modernist rules of neutrality and restraint.

But Helvetica was never truly gone. It quietly held its place and settled into a certain uber-cool humility, even starring in its own movie *Helvetica* in 2007.

Helvetica has prompted dozens of imitations, like Arial and MS Sans Serif, but also some iconoclastic parodies like Schmelvetica, Coolvetica, and Shatter, each with extraneous quirks and embellishments. In direct contrast to the 'spare and rational' ethos of Helvetica, such parodies are considered by purists as highly conflicted, and even sacrilegious.

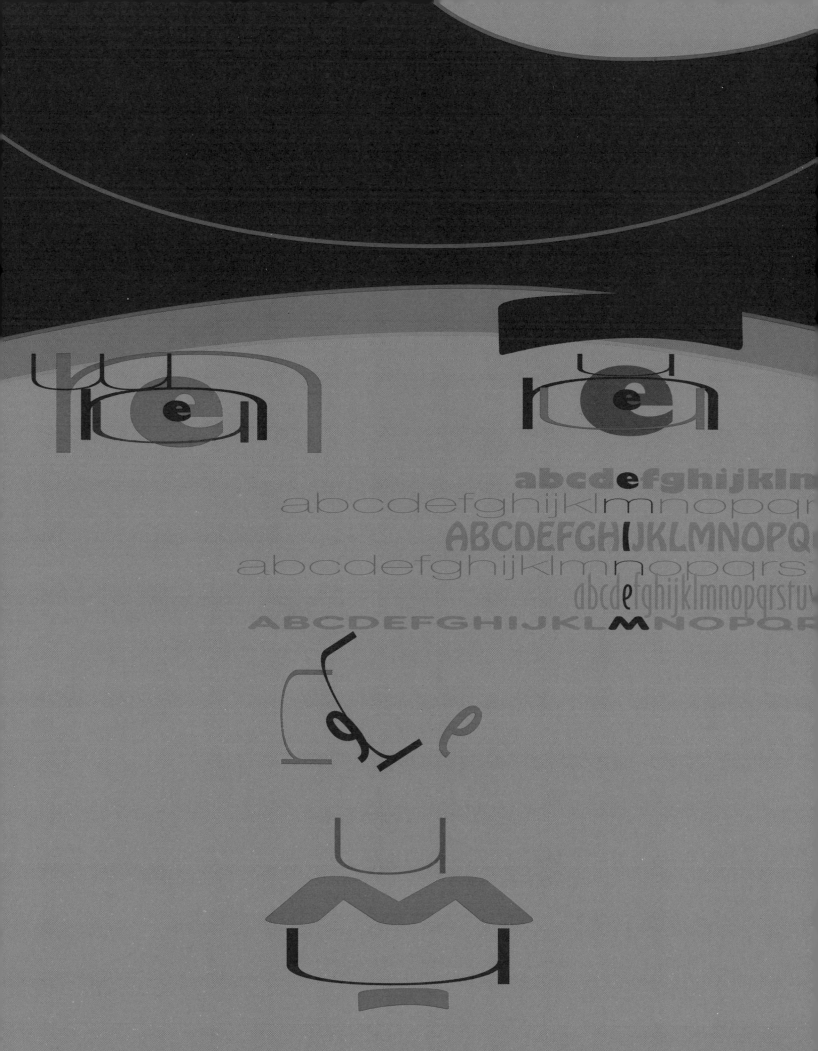

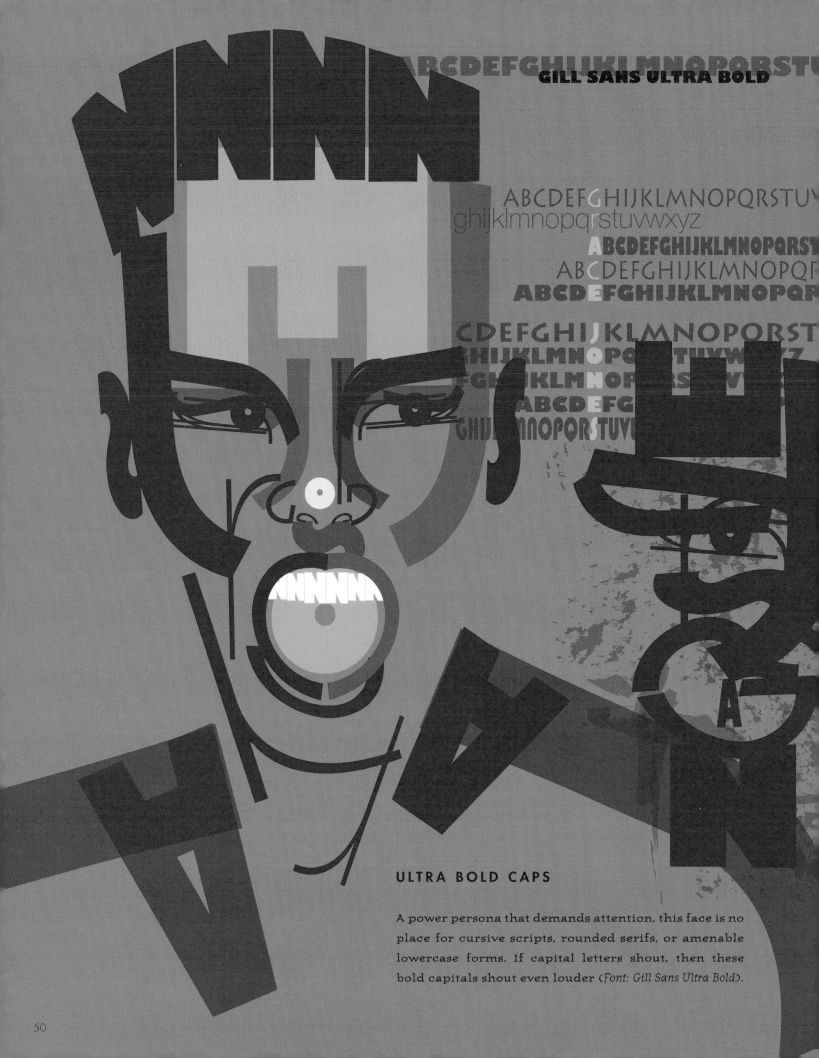

GILL SANS ULTRA BOLD

ULTRA BOLD CAPS

A power persona that demands attention, this face is no place for cursive scripts, rounded serifs, or amenable lowercase forms. If capital letters shout, then these bold capitals shout even louder (*Font: Gill Sans Ultra Bold*).

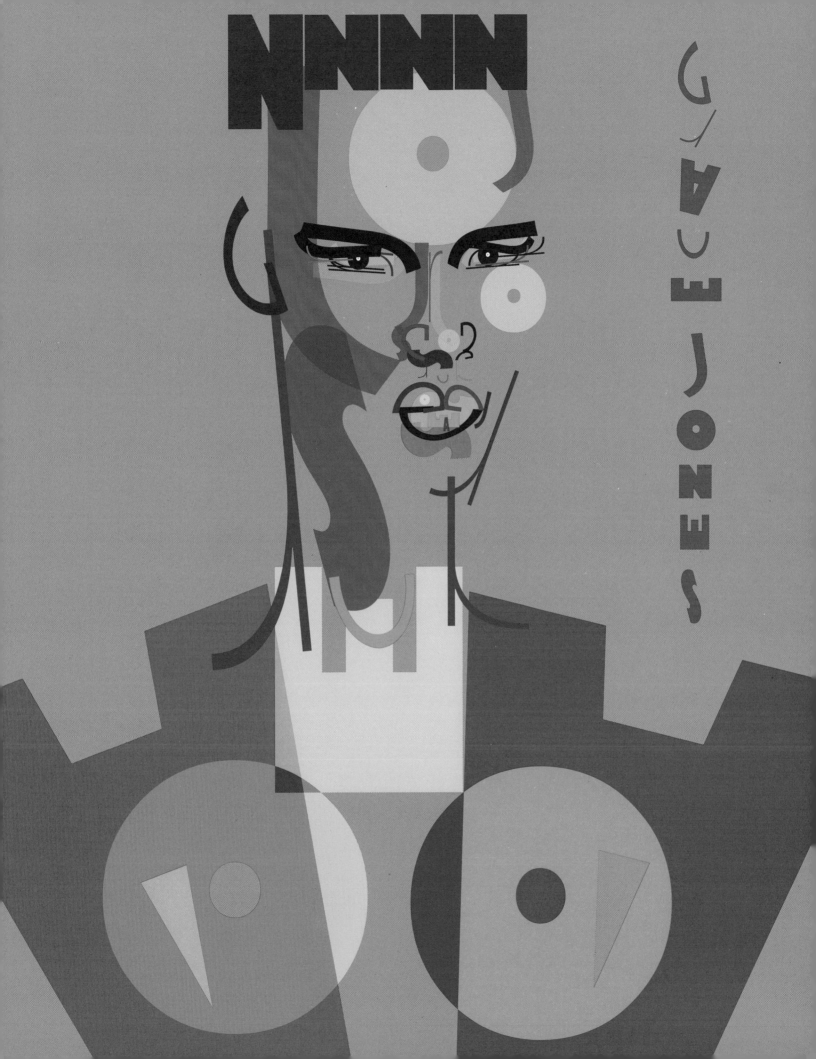

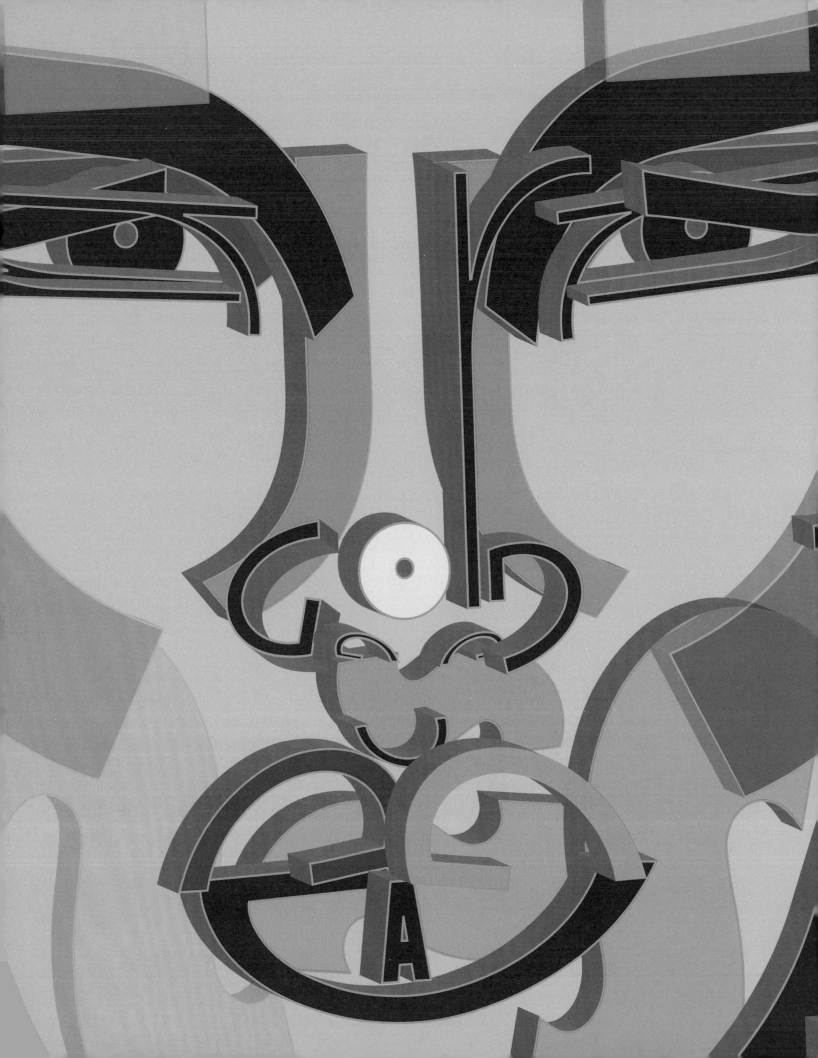

ECONOMY

The ideal Fontigram uses only one glyph allocated
to each letter of the name, with no repeats at all.

ULTRA BOLD LOWERCASE

Big, bold features require big, bold fonts, but for this face it's not capitals but the more intimate, rounded aesthetic of lowercase letter shapes 'e', 'a', and 'g' that are most simpatico (*Font: Gill Sans Ultra Bold, also known as Gill Kayo, from 'K.O.' for 'Knock-Out'*).

This highly personable font family was designed by Eric Gill in 1926. Gill Sans in its various weights is described as 'the British Helvetica' because of its lasting popularity in British design, and has been used everywhere from the modernist signage of the London Underground, to the deliberately simple covers of Penguin paperbacks.

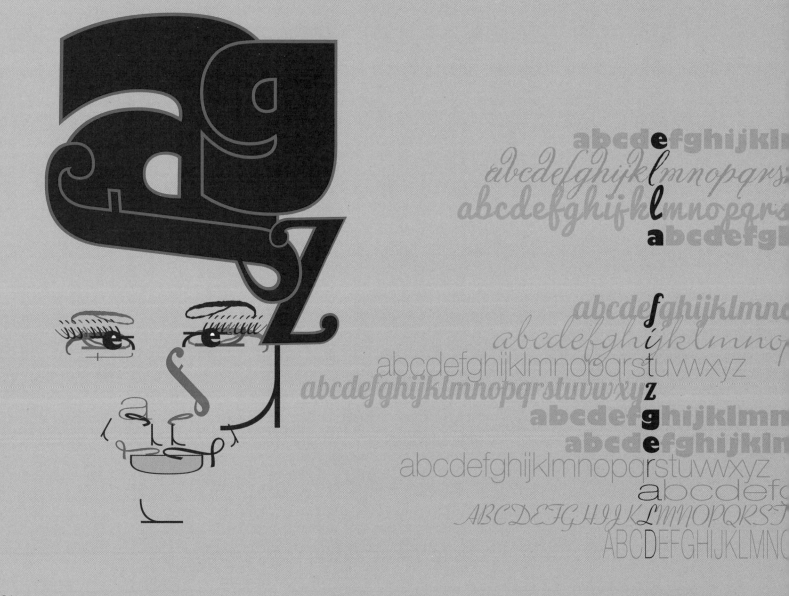

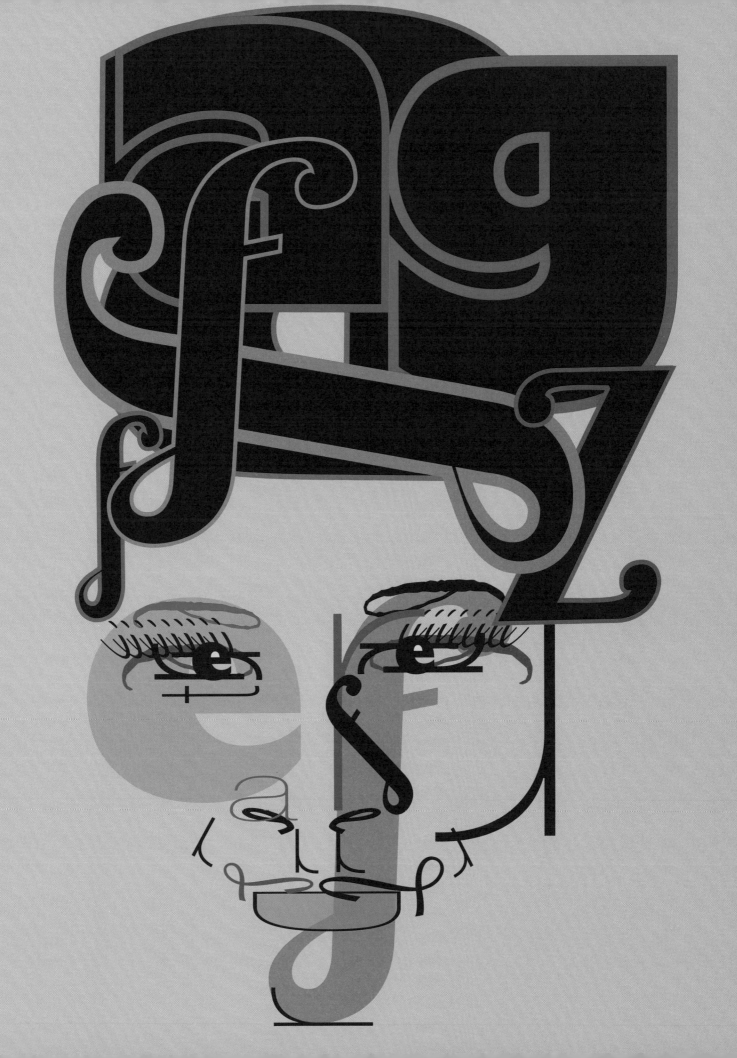

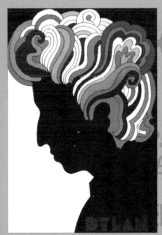

ICONIC

In an inspired combination of stark silhouette and phantasmagorical hair, design luminary Milton Glaser created this iconic likeness of Bob Dylan for a poster to accompany the *Greatest Hits* album in 1967.

The key to this Letter Art version is in the two shapes that create nose and mouth. First, an 'L' that works as that celebrated profile is found in a typeface reminiscent of relaxed handwriting (*Font: Biffo*). But it's the lowercase 'y' that seals the portrait, adding both mouth and curls (*Font: Fontesque Text Bold Italic*). Designed in 1994 by Canadian Nick Shinn, Fontesque was inspired by Shinn's own loose yet polished marker-pen renderings of type for layouts in the pre-digital era. Fontesque letters feel 'alive'; the fidgety serifs refuse to sit flat on a baseline; the unruly characters bulge and arc, but retain a sort of dancing gorgeousness that is irresistible. Individually coloured concentric inlines add '60s psychedelia, and help to unify a cursive 'y' and solid 'O' (*Font: Gill Sans Ultra Bold*).

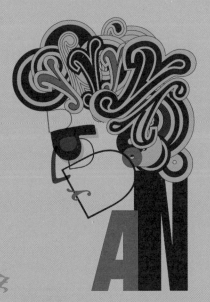

ABCdefghijklmnopqrstuvwxyz
Fontesque Text Bold Italic

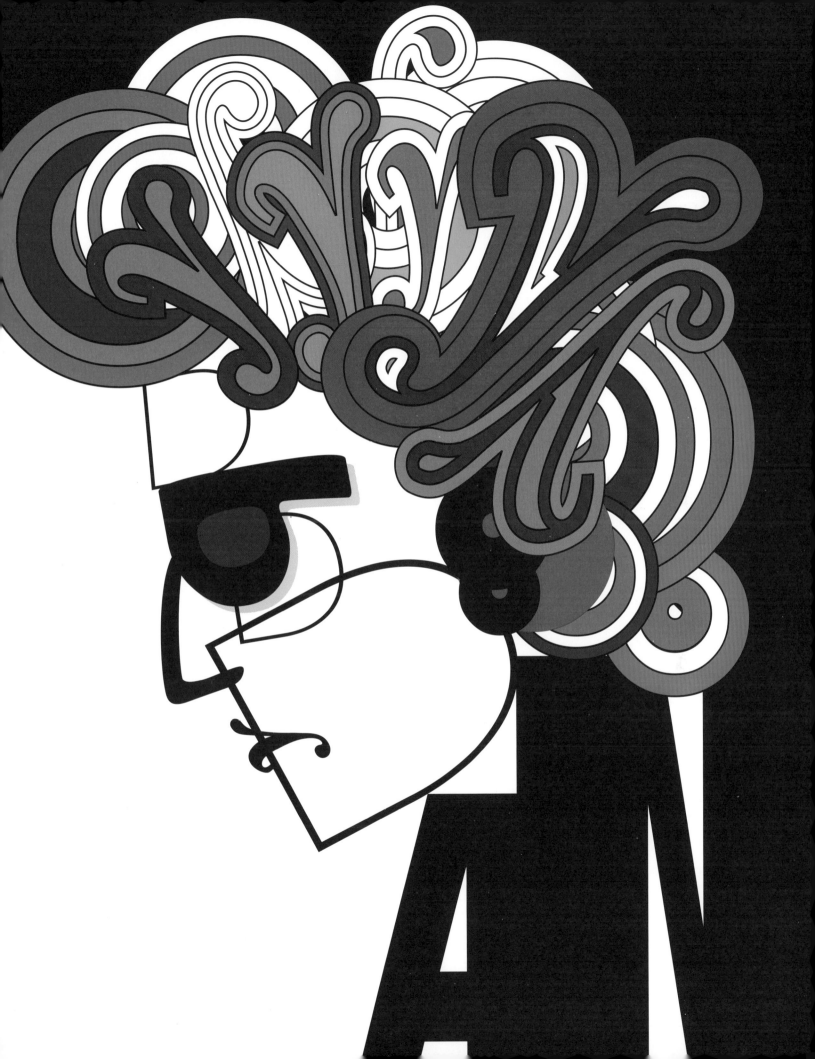

POETIC LINES

Craggy facial lines are drawn here with fine sans serif letters (*Font: Helvetica Neue 25*) and a distinctive calligraphic lowercase 'h' (*Font: Zapfino*). Two capital 'D' shapes create this famous fedora (*Font: Hobo*), while a lowercase 't' becomes a beret, opposite (*Font: Gill Sans Ultra Bold*).

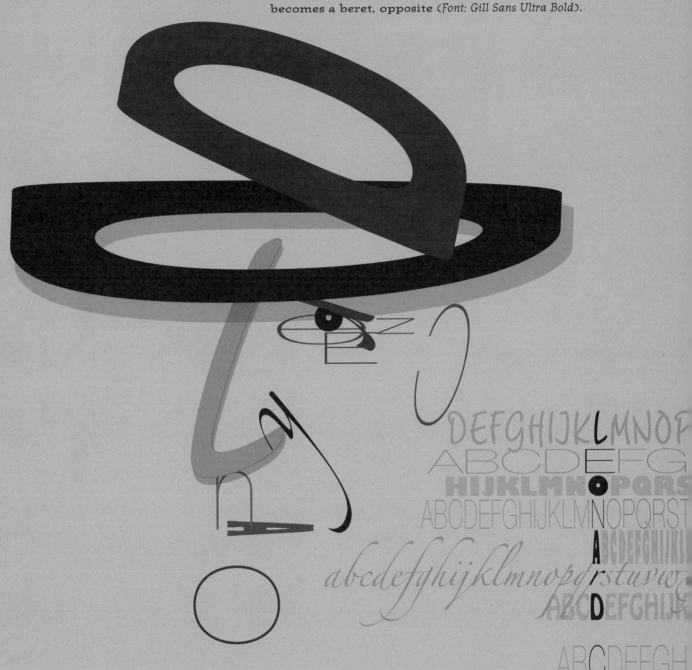

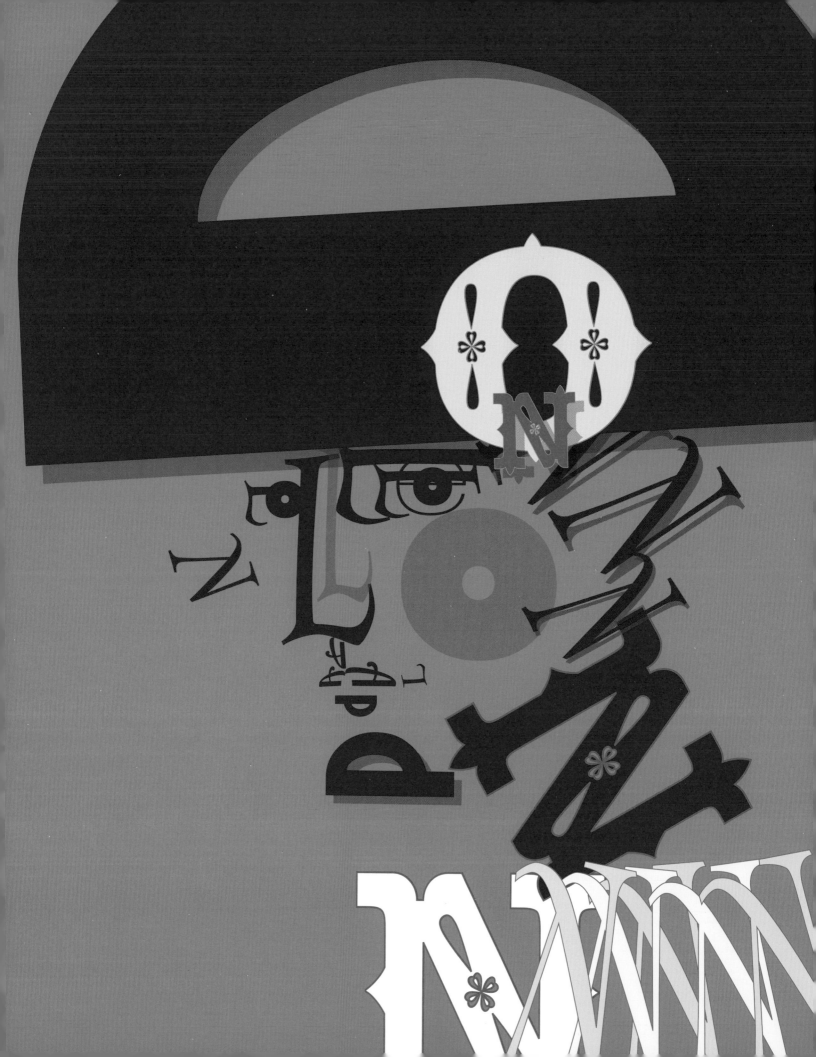

ABCDEFGHIJKLMNOPQRSTT

ABCDEFGHIJKLM

ABCDEFGHIJKLMNOPQRSTUVWXYZ

ABCDEFGHIJKLMNOPQRSTUV

ABCDEFGHIJKLMNOPQRS

abcdefghijklmn

ABCDEFGHIJKLMNOPQRSTUV

ABCDEFGHIJKLMNOPQRSTU

BRANDISM I

A master of personal branding, Napoleon emblazoned his world with an eponymous capital 'N' insignia. Here, a Tuscan 'O' and 'N' create badge, bib and collar (Font: Calavera Five), while a Gallic nose, brow, hair and epaulettes are drawn with restless serif letters 'L' and 'N' (Font: Fontesque).

Proving that almost any letter can create any feature, the arc of an unusual capital 'A' (Font: Lobster) draws a fussy yet commanding pout. Designed in 2010 by Argentinian type designer Pablo Impallari, Lobster is inspired by Art Nouveau letterforms noted for their embellished stroke endings and swash crossbars.

ABCDEFGHIJKLMNOPQRSTUVWXYZ

Lobster

UPPERCASE/LOWERCASE

The combination of capitals and lowercase letters is said to aid legibility because of the word shapes that are created by the irregular mix of capitals, ascenders and descenders. Nonetheless, the status and use of capitals has waxed and waned across the centuries, and from time to time the quest arises among modern type designers to create the ultimate typeface: one that has only one case (unicameral), thus eliminating the need for dual case complexities.[8]

Variex is a typeface that comes very close. Designed by Zuzana Licko and Rudy VanderLans, co-founders of Emigre type foundry in the 1980s, Variex capital and lowercase letterforms are almost identical. The Variex 'M', when extended further, also provides the perfect pout.

AbcdefgHijkLMNopqrʃtuvwxyz
qbcdefgHijkLMNopqrʃtuvwxyz
variex

ABCDEFGHIJKLMNOPQRSTUVWXYZ
abcdefghijklm
abcdefghijklmnopqrstuvwxyz
ABCDEFGHIJKLMNOPQRSTUVW
abcdefghijklmnop
abcdefghijkln
ABCDEFGHIJKLMNO
abcdefghij
abcdefghijklmnopqrstuvwxyz
abcdefghijklmnopqrstuvwxyz
ABCDEFGHIJKLMNOPQRST
abcdefghij
ijklmnopqrstuvwxyz

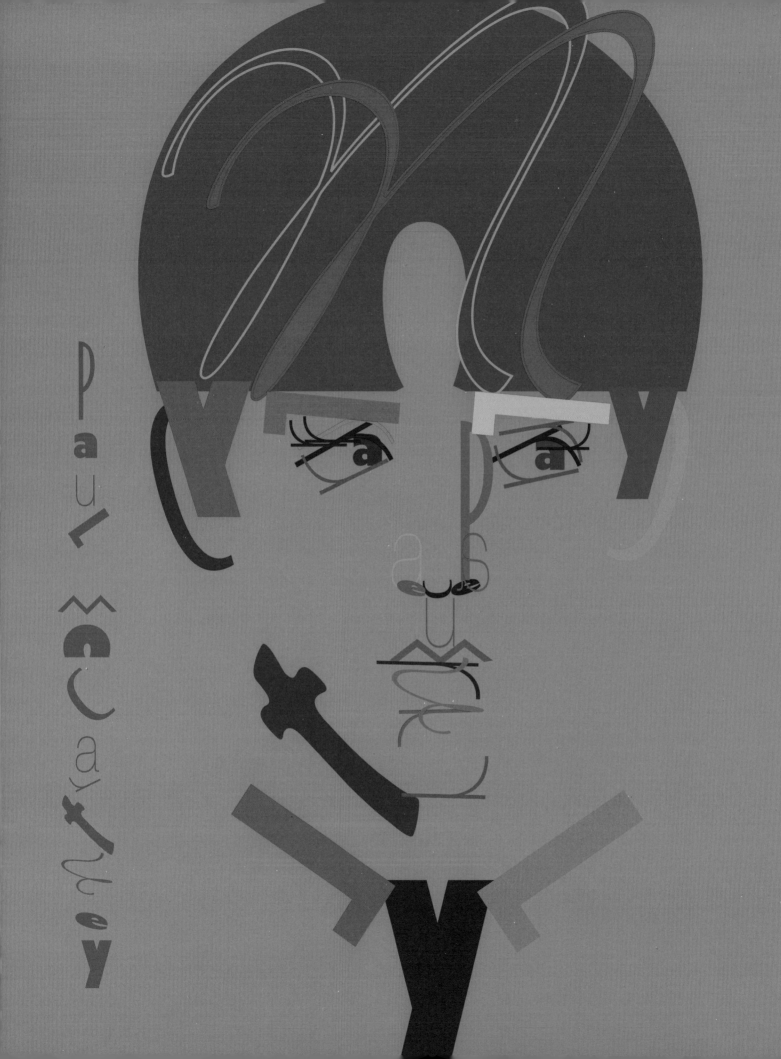

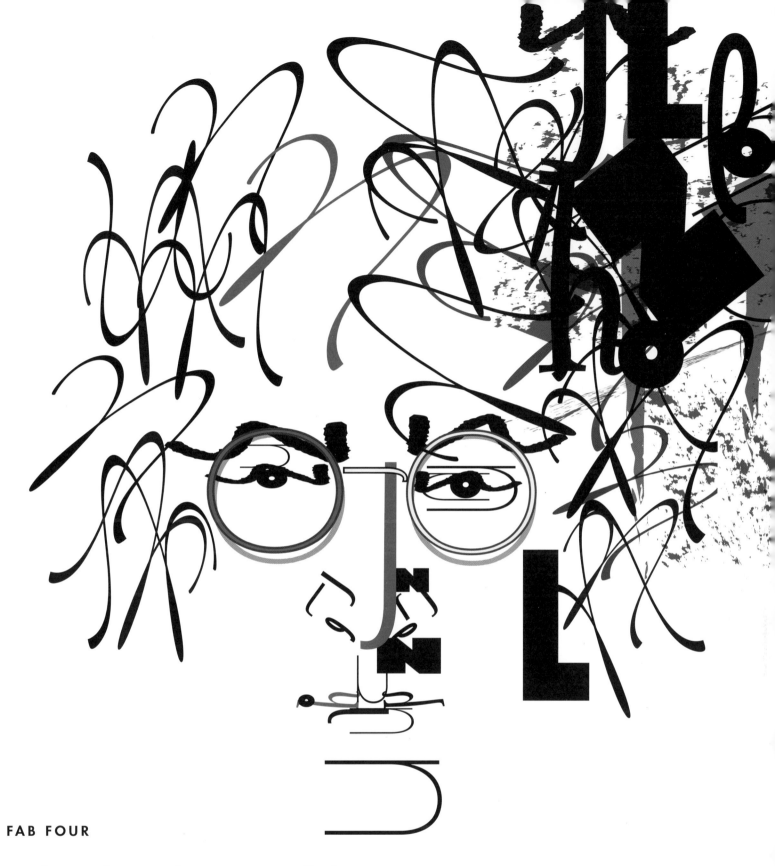

FAB FOUR

Four features of Lennon's face conspire to spell 'John':
that aquiline nose is a 'J' (*Font: BlockBuster*), those trademark
specs an 'O' (*Font: Helvetica Neue 25*), pursed lips are an 'h'
(*Font: Fontesque*), and curls, a capital 'N' (*Font: Bickley Script*).

ABCDEFGHIJKLMNOPQRSTUVWXYZ

LMNOPQRSTUVWXYZ

bcdefghijklmnopqrstuvwxyz

KLMNOPQRSTUVWXYZ

DEFGHIJKLMNOPQRSTUVWXYZ

abcdefghijklmnopqrstuvwxyz

lmnopqrstuvwxyz

fghijklmnopqrstuvwxyz

LMNOPQRSTUVWXYZ

KLMNOPQRSTUVWXYZ

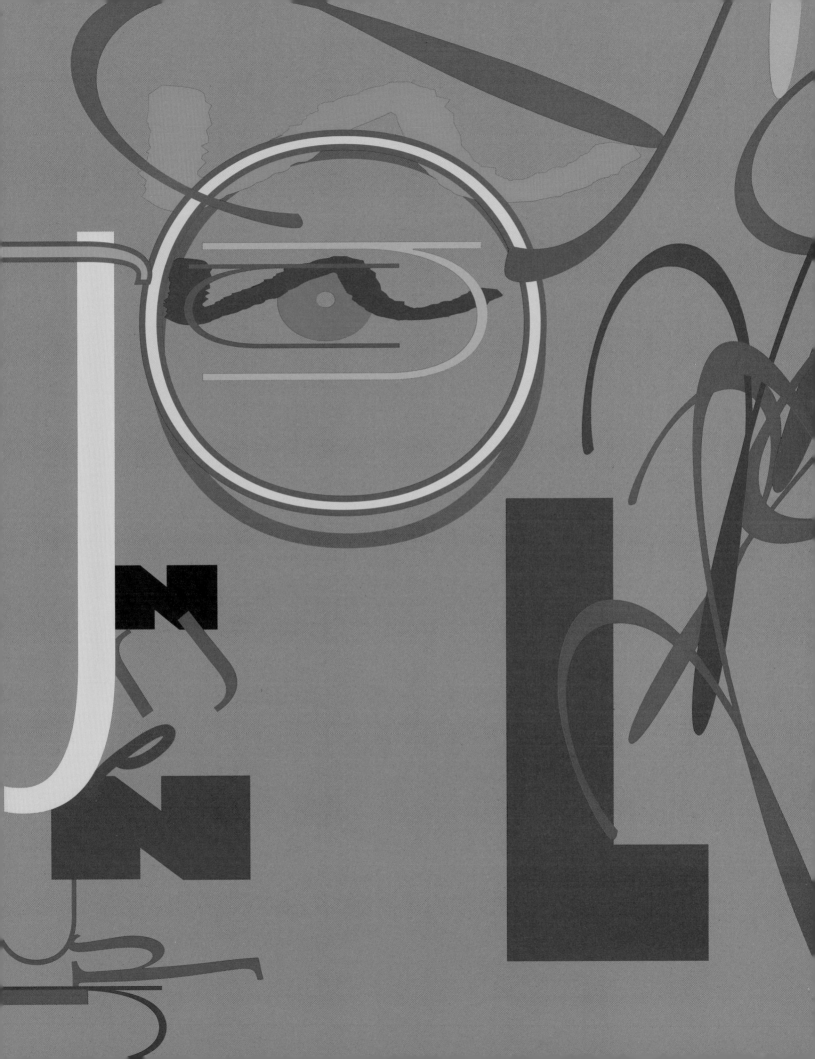

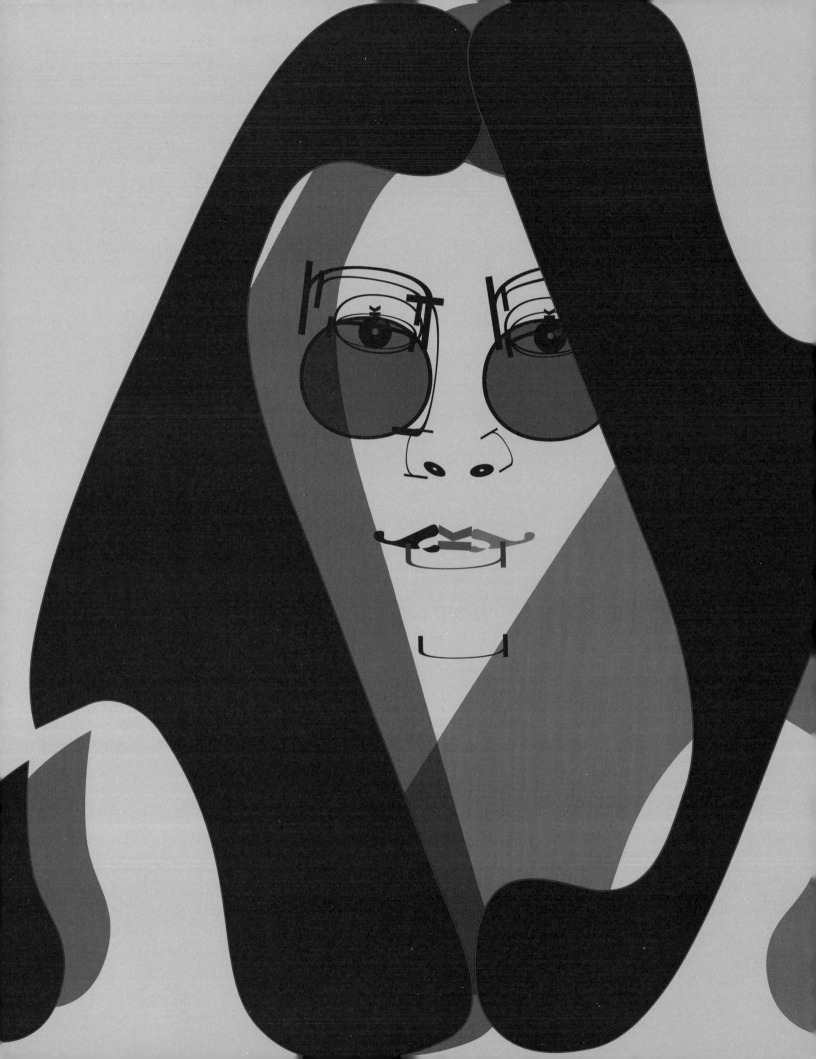

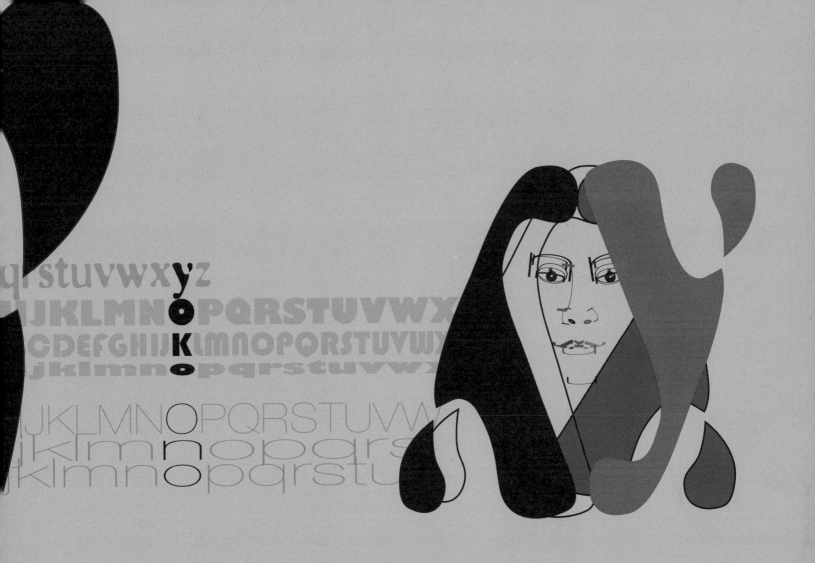

SILHOUETTE

This montage of quite limited letter shapes creates an inverted triangle, mountain-shaped and simpatico with the compelling gravitas of Ono herself. The name offers an oversupply of 'O' shapes, leaving little but an extended lowercase 'n' *(Font: Helvetica Neue 25)* to do most of the structural work. But the most serendipitous shape here is the softly formed 'y' *(Font: Flo Motion)* that is bold and curved enough to complete both hair and mouth. Designed by Peter Saville in 1992, Flo Motion was inspired by experiments in typographic photo-exposure that can melt and even break contours as letterforms slip gently in and out of focus.

ABCdefghijklmnopqrstuvwxyz
Flo Motion

▲ Greek lapidary letters, 5th century BCE, based on the Phoenician alphabet

SIMPLE SANS

This uncomplicated character is drawn with a selection of equally direct sans serif typefaces. A Beatles' mop-top is made with simple 'S' shapes (*Font: Lithos Regular*), while neat, mod clothing is constructed with an 'A' and 'N' from a bolder version of the same typeface (*Font: Lithos Bold*).

ABCDEFGHIJKLMNOPQRSTUVWXYZ

LITHOS

Lithos was designed by American designer Carol Twombly in 1989, resurrected from ancient, austere inscriptions on 5th century BCE Greek monuments. Lithos reflects those Spartan traits: spare, frugal, enduring, monoline and 'unicameral', with uppercase letters only.

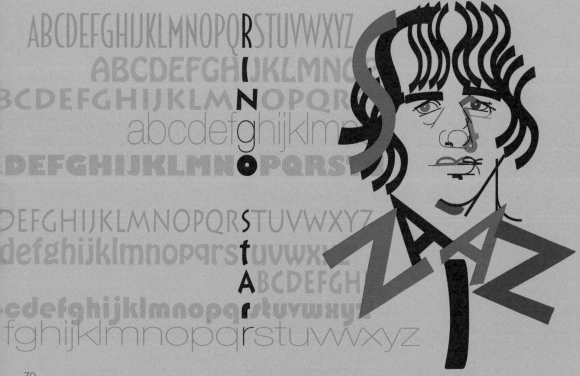

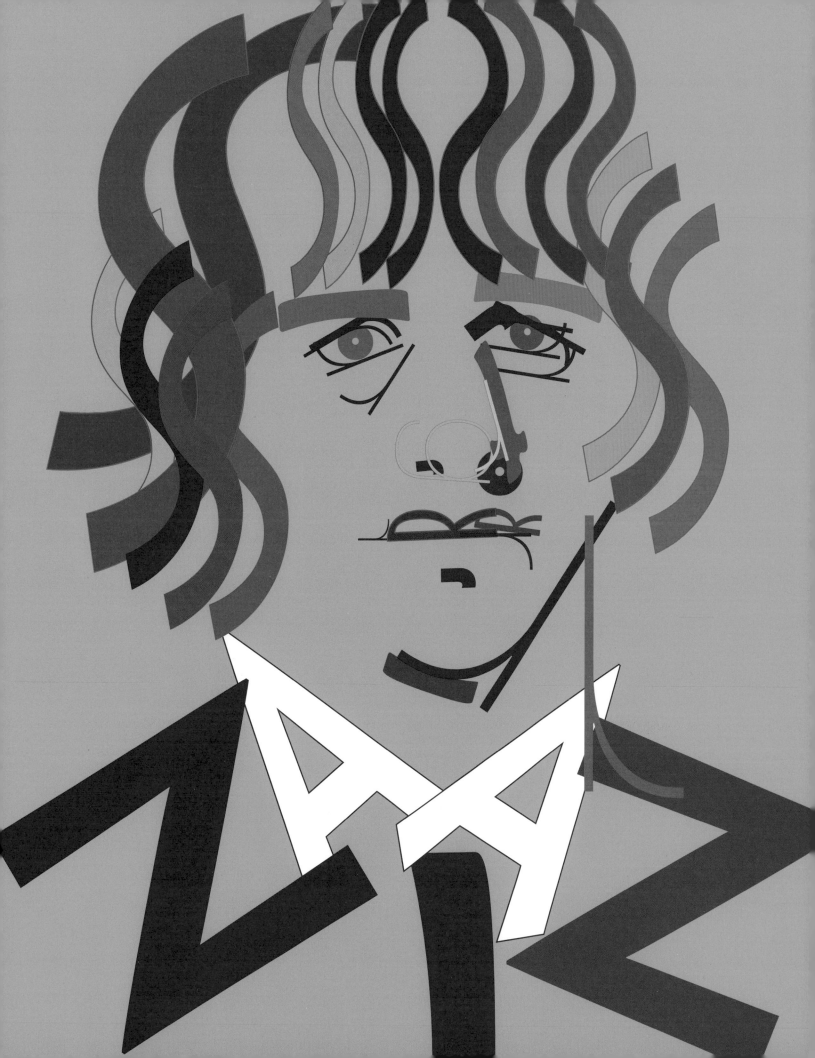

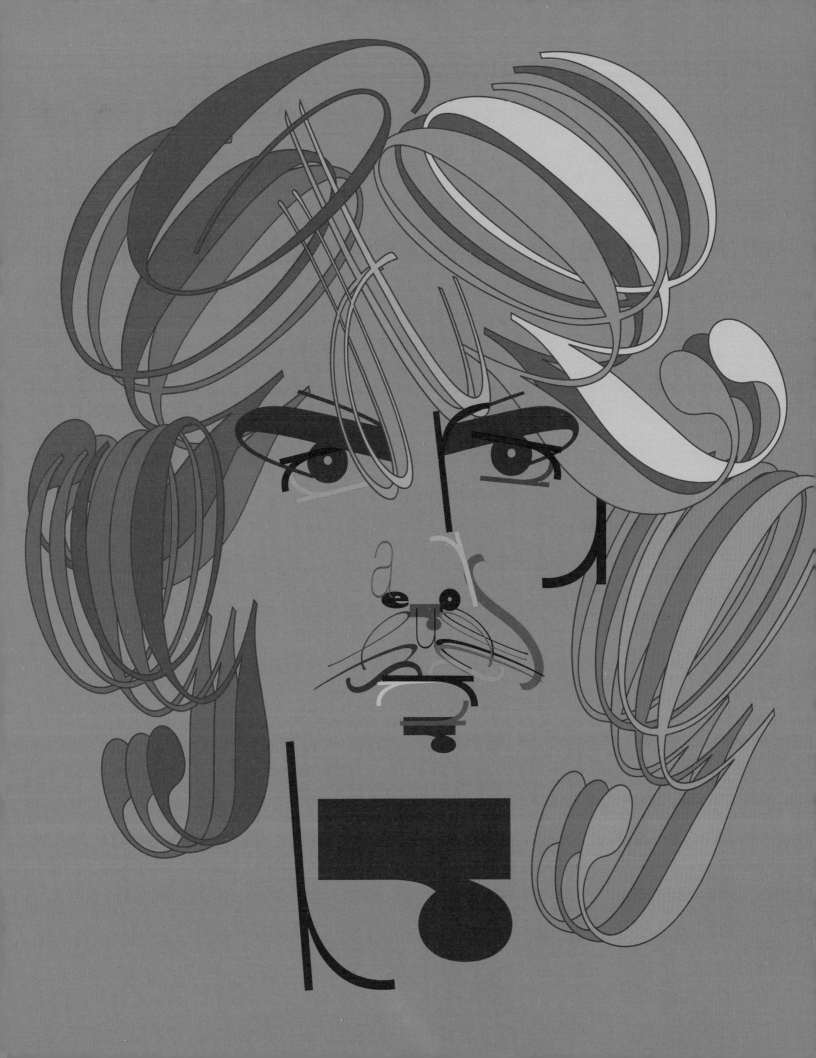

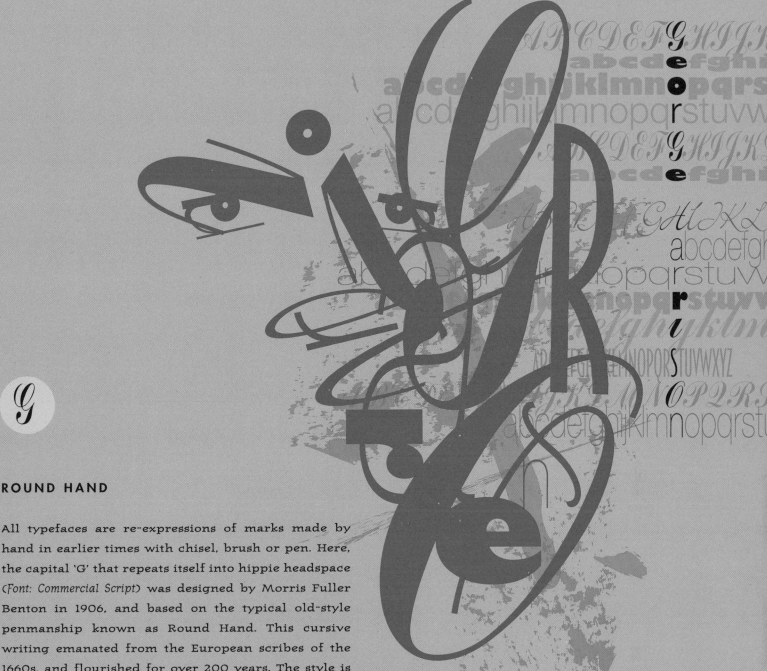

ROUND HAND

All typefaces are re-expressions of marks made by hand in earlier times with chisel, brush or pen. Here, the capital 'G' that repeats itself into hippie headspace (*Font: Commercial Script*) was designed by Morris Fuller Benton in 1906, and based on the typical old-style penmanship known as Round Hand. This cursive writing emanated from the European scribes of the 1660s, and flourished for over 200 years. The style is characterised by its oblique, oval-based shapes, contrasting thicks and thins, linked letters, and measured neatness. It was also known as 'copperplate' script, because it was popularly etched directly into copper plates for print reproduction.

In the US, the style was called 'Spencerian' script, after Platt Rogers Spencer who developed and widely taught such writing from the 1840s onward. It became the standard for American personal, business, and banking correspondence from the mid-1800s right up until the first 'qwerty' keyboard typewriter changed everything in the 1920s. The logos of Coca-Cola and Ford exemplify Spencerian script from the late 1800s.

Commercial Script

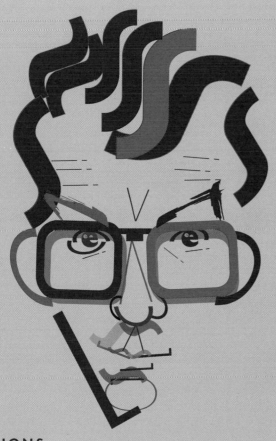

OPTIONS

This portrait (above) of a high and hatless hairline features quizzical brows made with a capital 'L' and a lowercase 'l', both from the same animated brush script (*Font: Ru'ach*). The second portrait (opposite page) is further reduced to the ideal Fontigram with only one glyph per letter, and no repeats. It uses a different 'L' for brows (*Font: Flo Motion*), and a distinctive pork-pie hat shape is made by the extreme extension of a capital 'T' (*Font: Gill Sans Ultra Bold*).

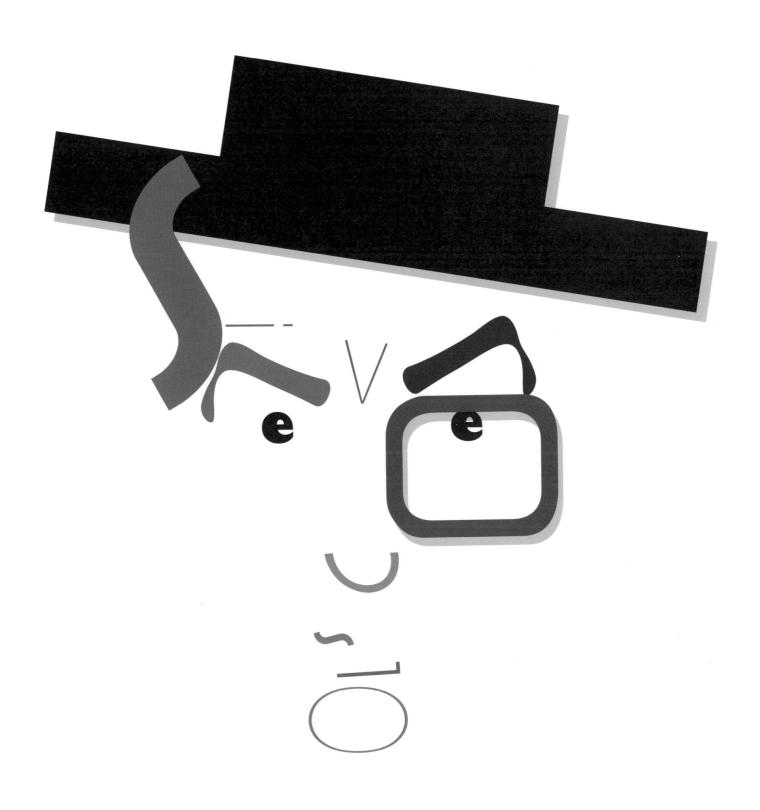

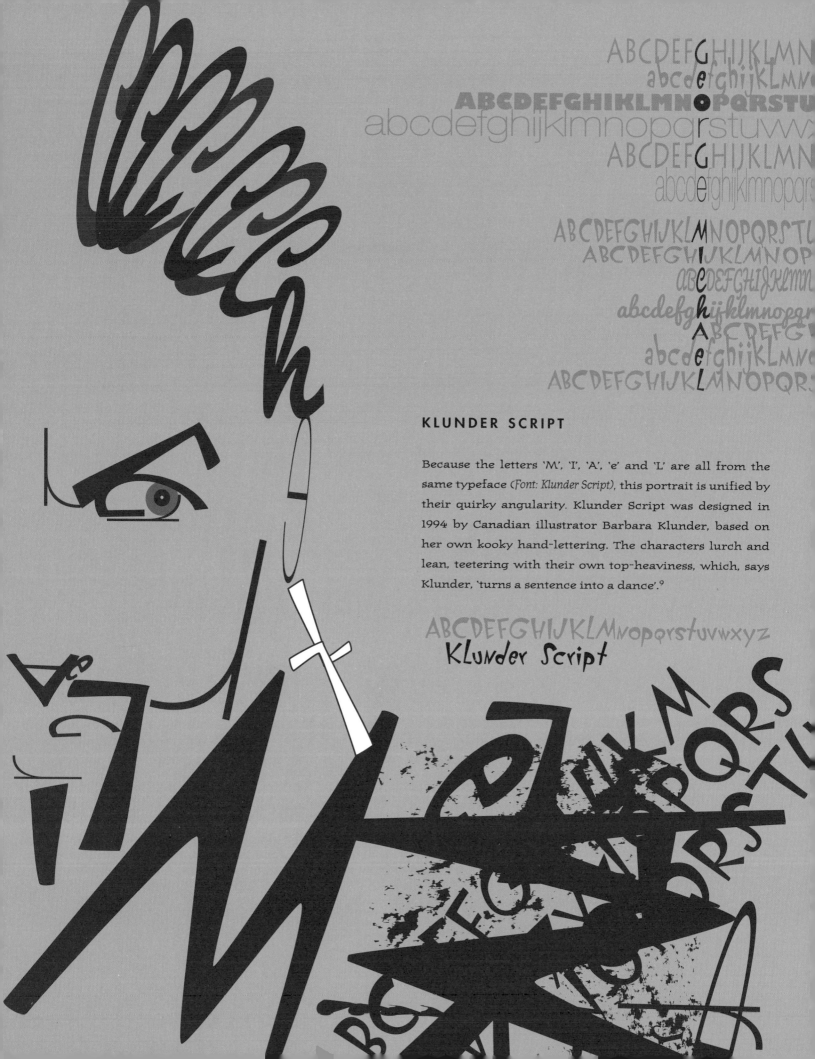

KLUNDER SCRIPT

Because the letters 'M', 'I', 'A', 'e' and 'L' are all from the same typeface (*Font: Klunder Script*), this portrait is unified by their quirky angularity. Klunder Script was designed in 1994 by Canadian illustrator Barbara Klunder, based on her own kooky hand-lettering. The characters lurch and lean, teetering with their own top-heaviness, which, says Klunder, 'turns a sentence into a dance'.[9]

ABCDEFGHIJKLMnopqrstuvwxyz
KLunder Script

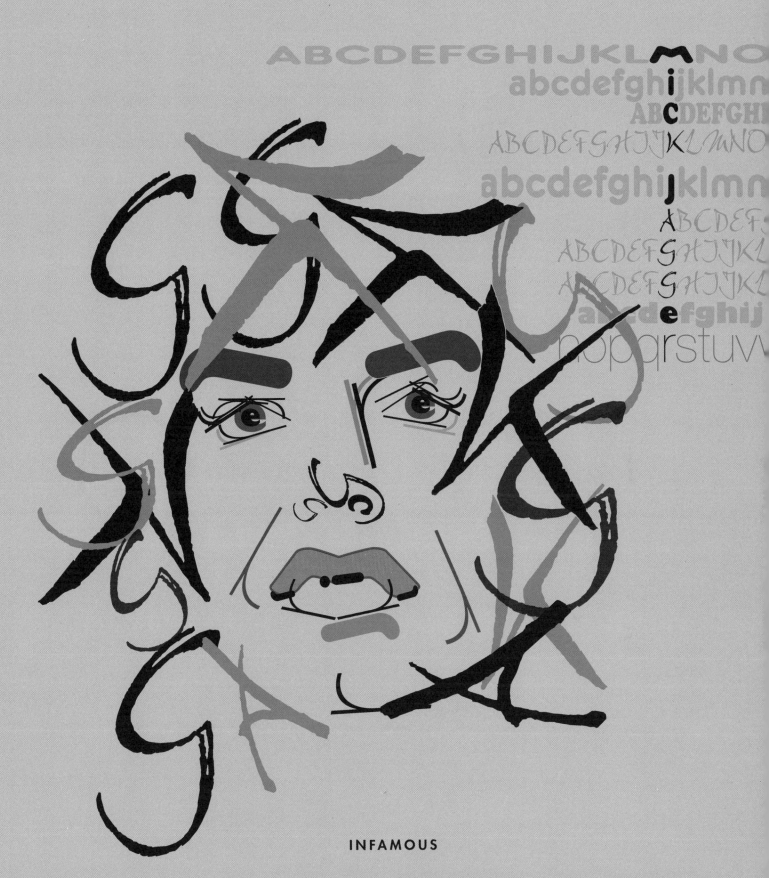

INFAMOUS

These legendary lips are in fact an extended, rounded
capital 'M' and lowercase 'i' (Font: Frankfurter), while a chaos
of rock'n'roll curls is a tangle of sketchy capitals 'G', 'K'
and 'A' from a calligraphic script (Font: Bergell Plain).

ASYMMETRY

There is little about any face that is symmetrical. This is exotically true with David Bowie, whose eyes appear to be different colours. However, Bowie's condition is in fact anisocoria, the result of damage from a teenage fist fight which left one pupil permanently dilated. Photographed by Brian Duffy for Duffy Design Concepts in 1973, the *Aladdin Sane* album cover is arguably the most well known of the Bowie portraits, with its emphasis on those asymmetric eyes and striking lightning-bolt makeup.

In this Letter Art version, a capital 'O' delivers Bowie's unique gaze (*Font: Antique Olive Compact*), and a 'W' is extended for the makeup flash, nose, and lips (*Font: Klunder Script*).

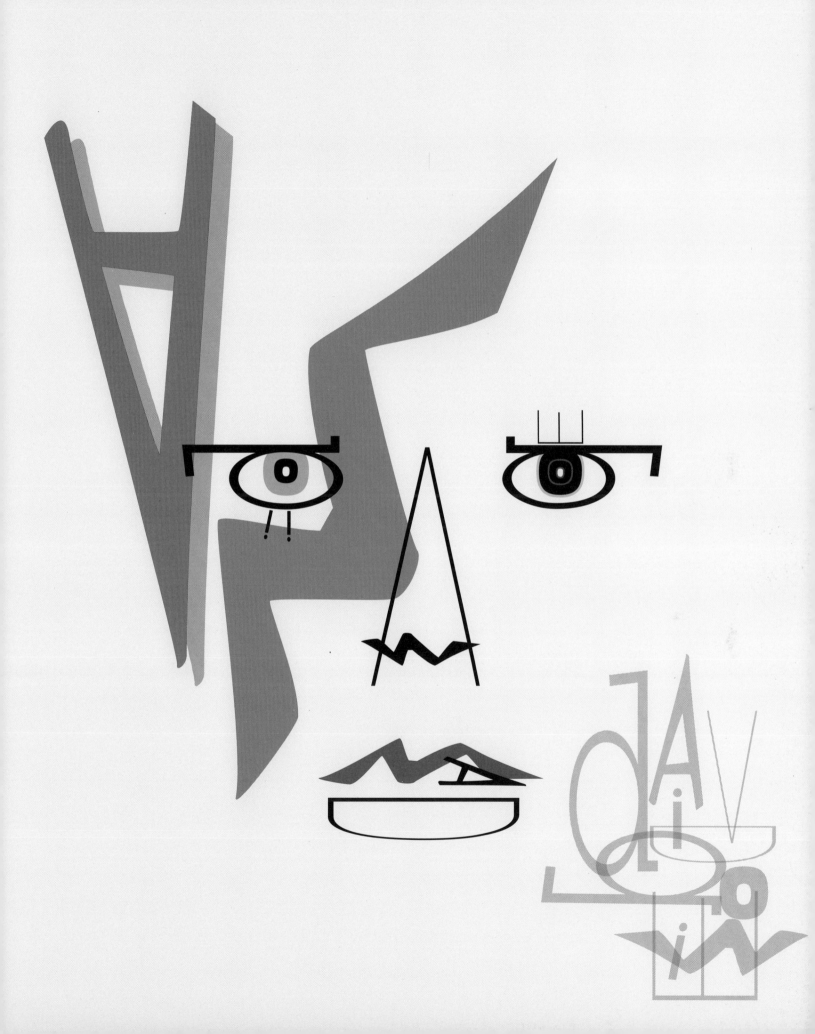

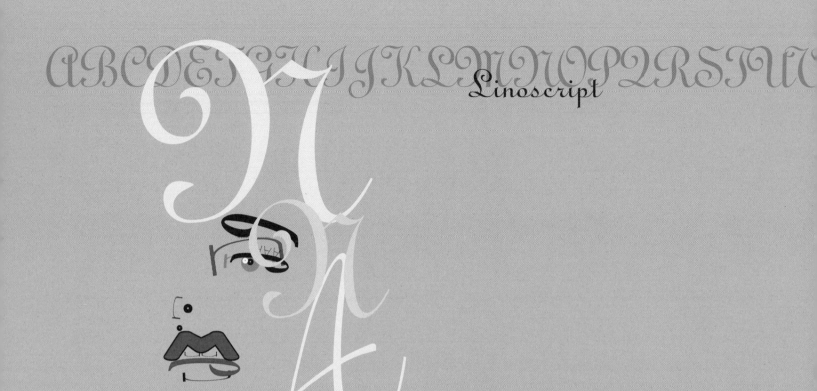

DECADENCE

A true chameleon, this diva has a hundred different looks to her name. This portrait describes her 1980s' pop-punk persona: all curls and eyebrows. There are few arching shapes available in the letters of this name, so this likeness relies heavily on a rounded Gothic-style lowercase 'd' to make eyelids, eyebrows, and that tortured, bitten, bottom lip (Font: Fontesque Bold Italic). But it's the tousled hair rendered in chocolate-box capitals that delivers just the right amount of 1980s' girly mess (Font: Linoscript). Designed by Morris Fuller Benton in 1905, Linoscript's flowing lines exemplify fin-de-siècle upright French scripts of the Art Nouveau movement, characterised by flourished capitals with extravagant loops.

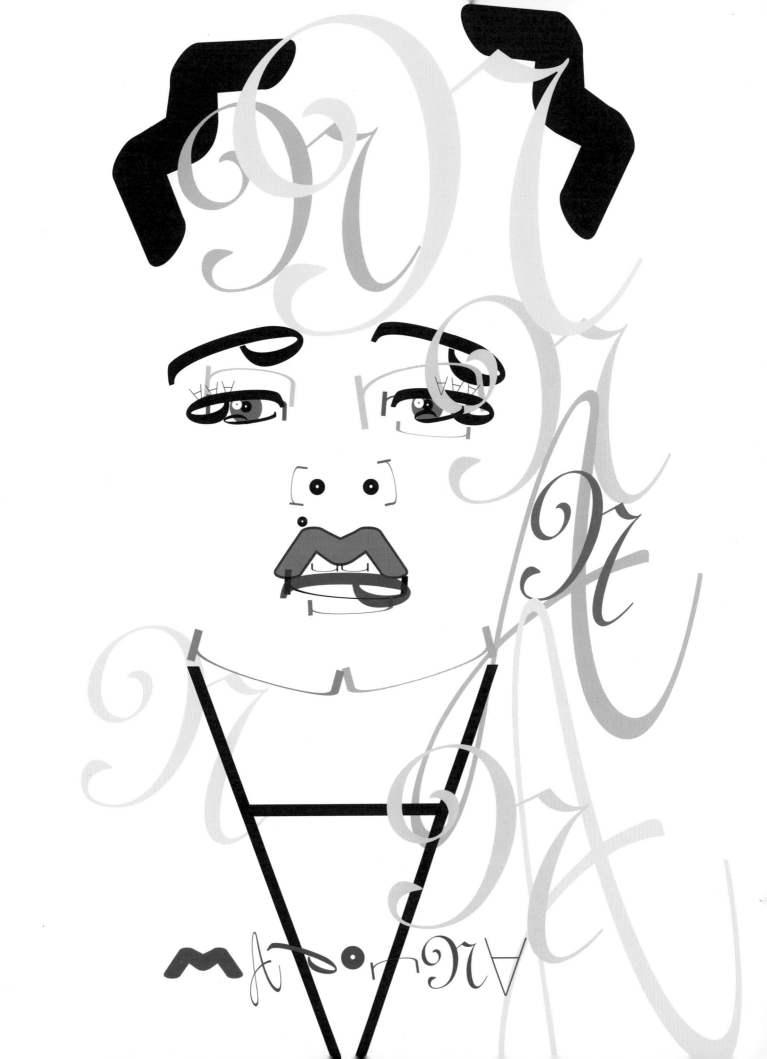

POWER HAIR

The same cursive script whose capital 'P' defies gravity
in one presidential outlook also delivers a 'B' and bearded
gravitas to another, opposite (*Font: Greyton Script*).

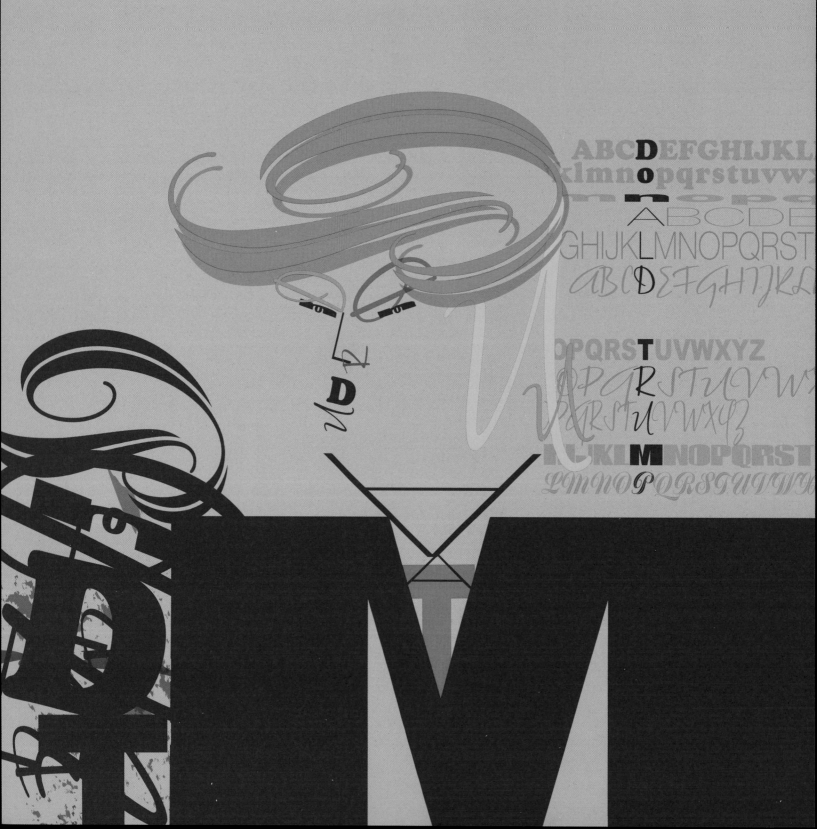

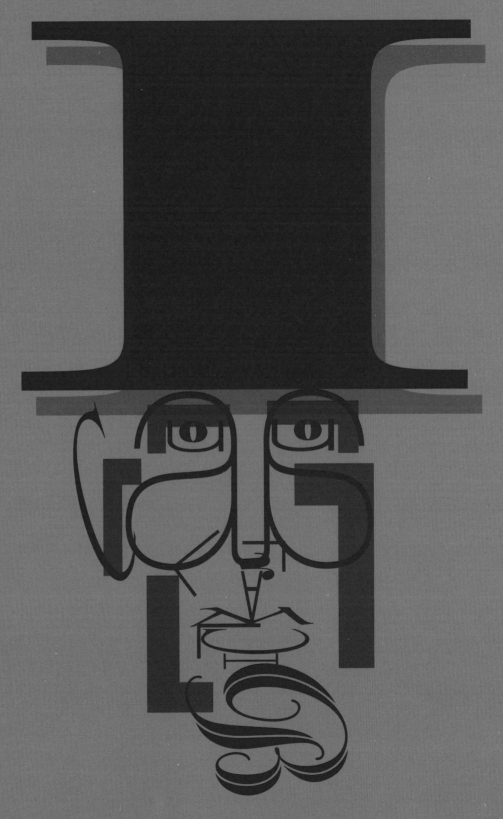

CALLIGRAPHIC

The elegant lowercase 'f' that provides hair and brow for this portrait (*Font: Zapfino*) was designed by Hermann Zapf. He had long wanted to create a typeface that was as beautiful as pen-drawn calligraphy, containing all the delicious ligatures and flourishes of his own handmade strokes.

His first attempt was made in 1948, but the 'hot metal' compositing technology of the time consisted of individual letters mounted on metal slugs that were sequentially arranged into words and sentences, and then cast in molten metal as a complete line. This system was incapable of rendering these bespoke free-flowing, under-lapping and over-hanging swash characters. Such a result could only be achieved using modern digital technology, and so it was not until 40 years later that Zapf and colleague David Siegel began again, this time working to create the complicated software necessary to make such a typeface possible. Siegel departed the project and was replaced by type designer Gino Lee who became the 'ino' in the final typeface name 'Zapfino', which was finished in 1998.

The result is a thing of beauty in its form as well as its function. As you type words using this typeface, the clever code changes letter pairs and alternative partners, especially ascenders, descenders and ligatures, automatically customising each glyph to its neighbour to give a beautiful, interlocked word that flows like bespoke calligraphy.

AabcdefghijklmnopqrstuvwxyzZ

Zapfino

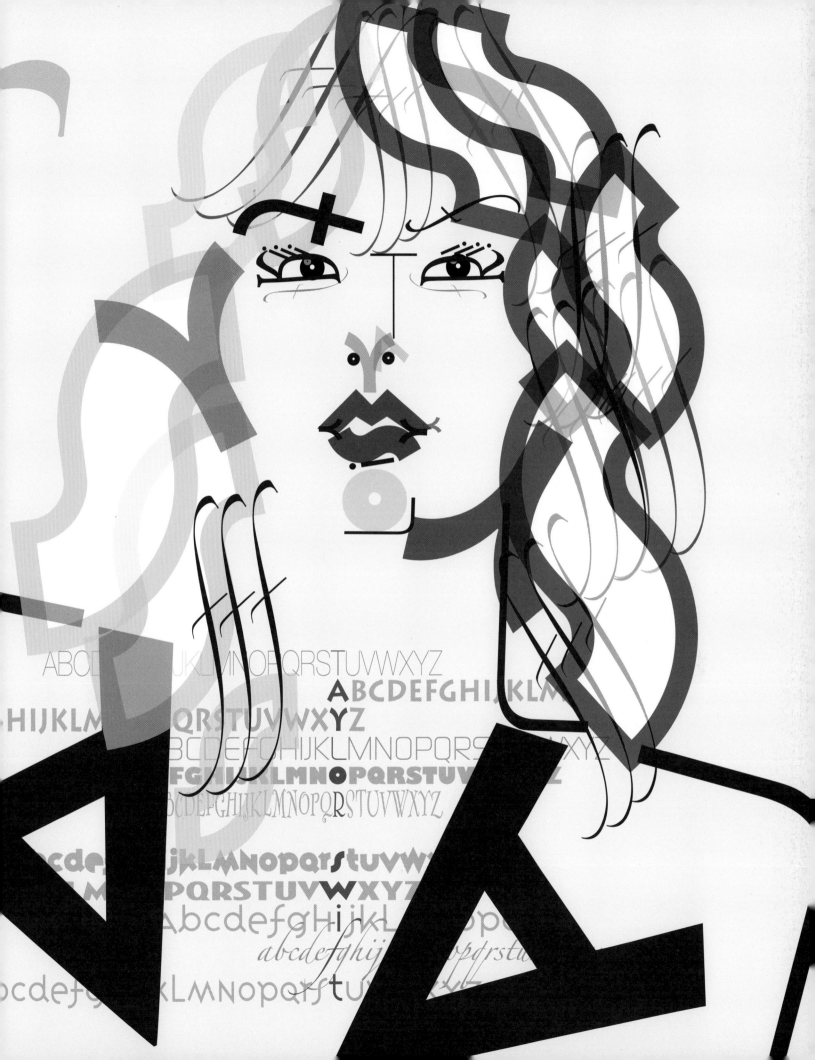

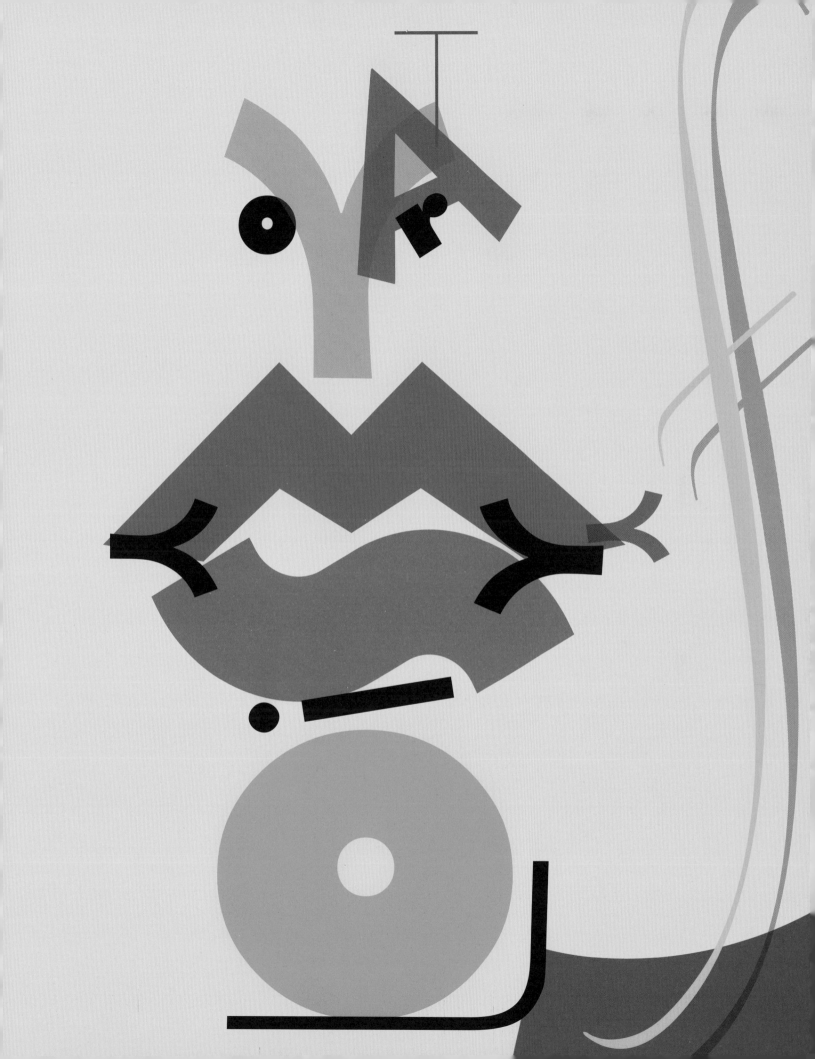

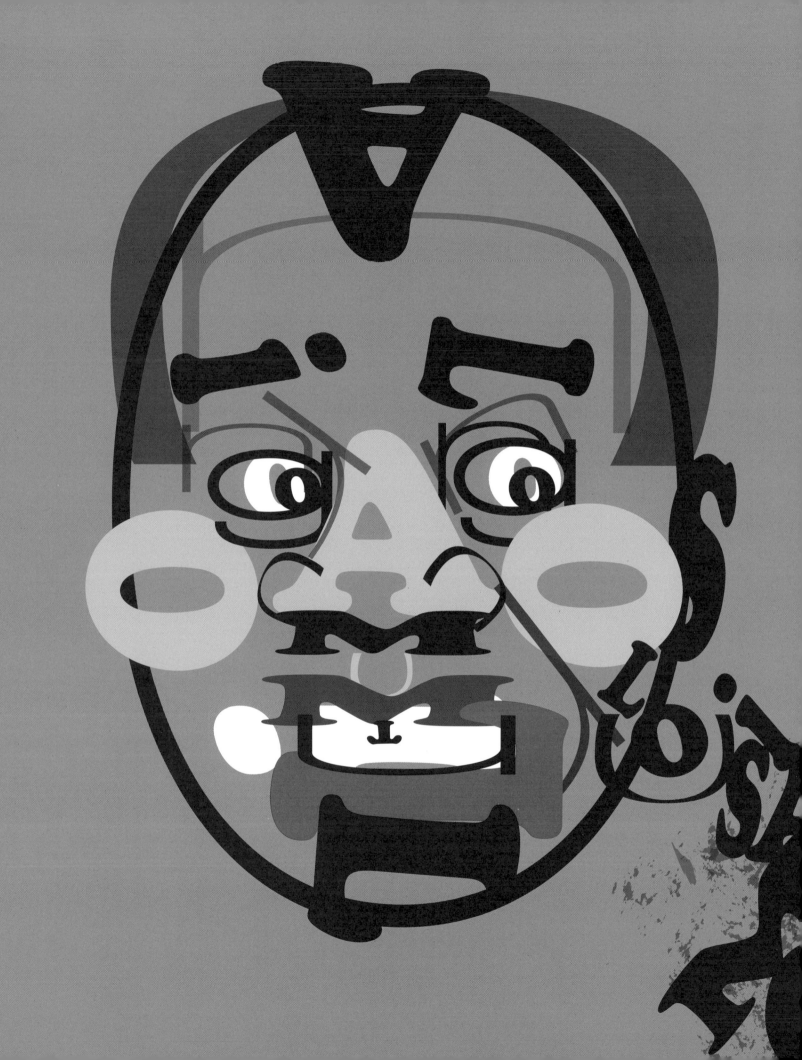

COOPER BLACK

This face is packed with animated lines, many drawn here in a cooperative linear sans serif (*Font: Helvetica Thin*). But if this man could be a typeface, he'd be a generous, plump serif font whose comfy curves hit just the right note for fat jazz sounds, a giant personality, and those big, bold facial features, found in letters 'L', 'O', 'i', 'S', 'A', 'M', and 'T' (*Font: Cooper Black*).

ABCDEFGHiJKL M NOPQRSTUVWXYZ

Cooper Black

DAD'S ARMY

Dancing Machine
JACKSON 5IVE

Garfield

easyJet

The
Beach
Boys Pet
Sounds

M*A*S*H

DIFF'RENT
STROKES

DOORS
L.A. WOMAN

DAVID BOWIE
ZIGGY STARDUST

FREAK OUT!
The Mothers
of Invention

Emmanuelle

{ ROBUR }

{ Auriol Black }

Designed by Oswald Cooper in 1922, Cooper Black imitates earlier typefaces Robur and Auriol Black, both designed by Georges Auriol two decades prior. While Cooper Black is less fussy and more streamlined than its precursors, it retains their unique swollen serifs and rounded, organic forms.

Cooper Black was used and overused right up into the 1960s and '70s when it became the default for both mainstream and counterculture graphics. It now represents the ultimate in nostalgia of the 'baby boomer' era. There's a promise of playfulness in this typeface, along with a familiar, accessible warmth and authority. Whether used in its base form or combined with sweeping italics or swash embellishments, Cooper Black has featured in a million happy messages from the title graphics for *Dad's Army* and *Cheers*, to the Garfield logo and the album cover of the Beach Boys' *Pet Sounds*. But curiously, this family-friendly typeface also found its way to the vertiginous edges of culture, including Frank Zappa's *Freak Out* of 1966, the Doors' *L.A. Woman* of 1971, Bowie's *Ziggy Stardust* of 1972, and title credits for risqué movie classic *Emmanuelle* of 1974.

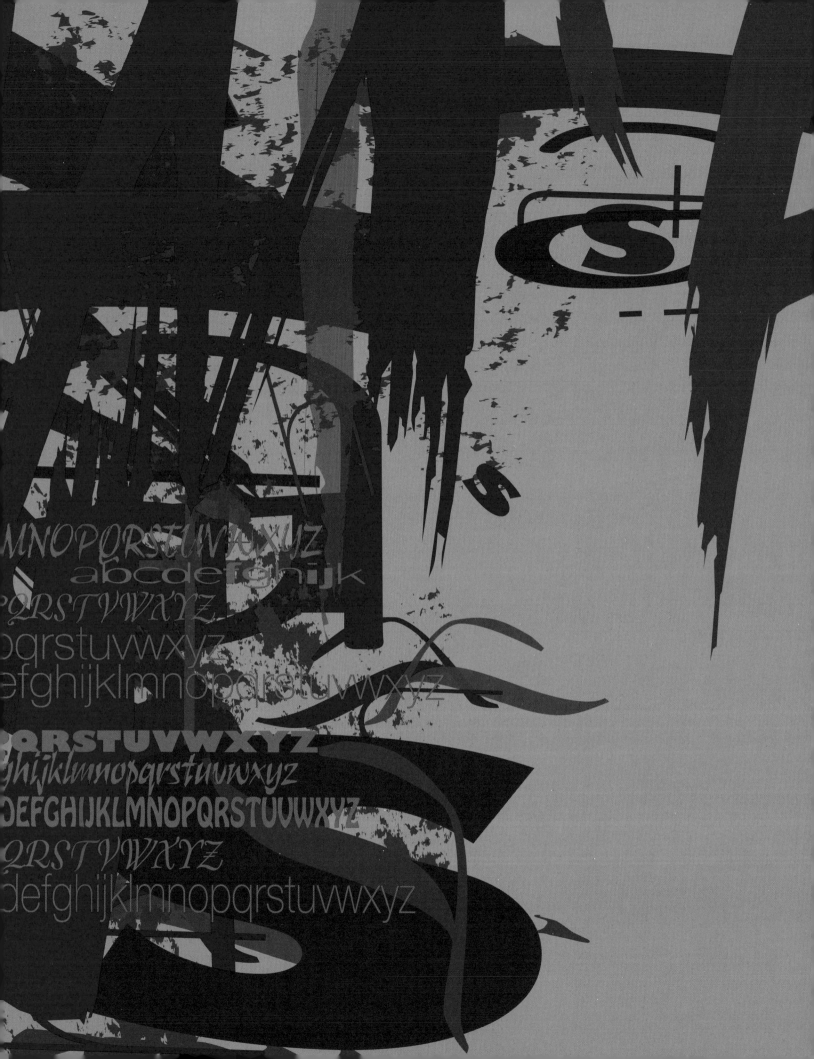

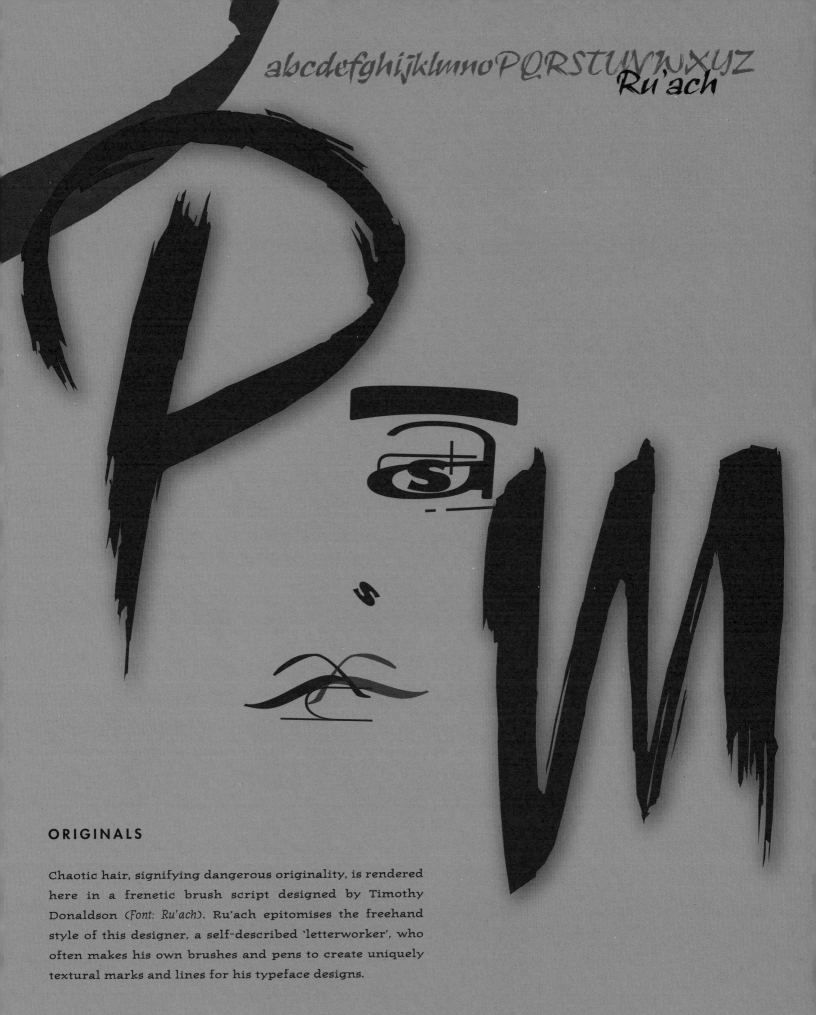

abcdefghijklmnoPQRSTUVWXYZ
'Ru'ach

ORIGINALS

Chaotic hair, signifying dangerous originality, is rendered here in a frenetic brush script designed by Timothy Donaldson (*Font: Ru'ach*). Ru'ach epitomises the freehand style of this designer, a self-described 'letterworker', who often makes his own brushes and pens to create uniquely textural marks and lines for his typeface designs.

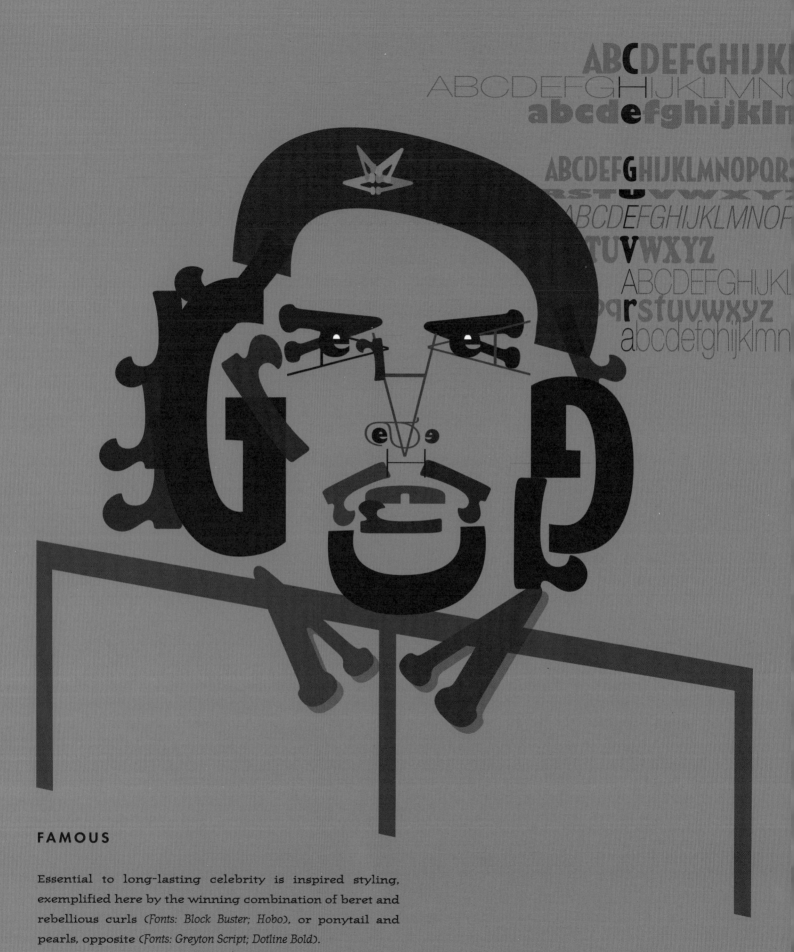

FAMOUS

Essential to long-lasting celebrity is inspired styling, exemplified here by the winning combination of beret and rebellious curls (Fonts: Block Buster; Hobo), or ponytail and pearls, opposite (Fonts: Greyton Script; Dotline Bold).

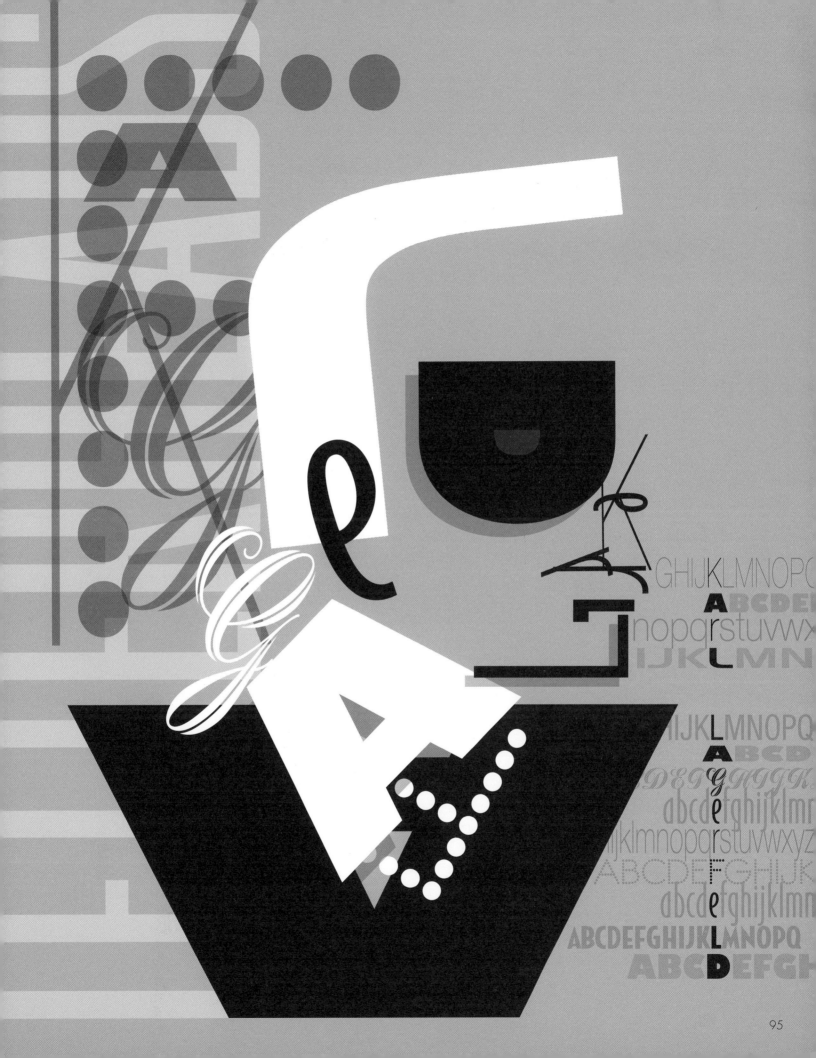

BatMan

96

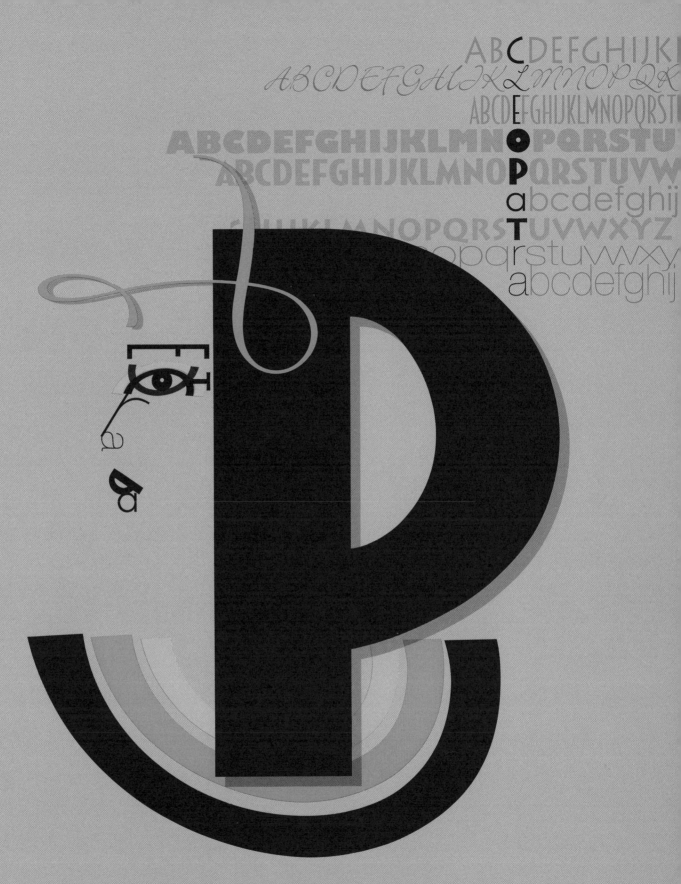

CLASSICS

A deco-style capital 'P' (*Font: Block Buster*) makes hair and lip detail for this iconic profile, with eyeliner and collar supplied by a classical antique sans 'C' (*Font: Lithos*).

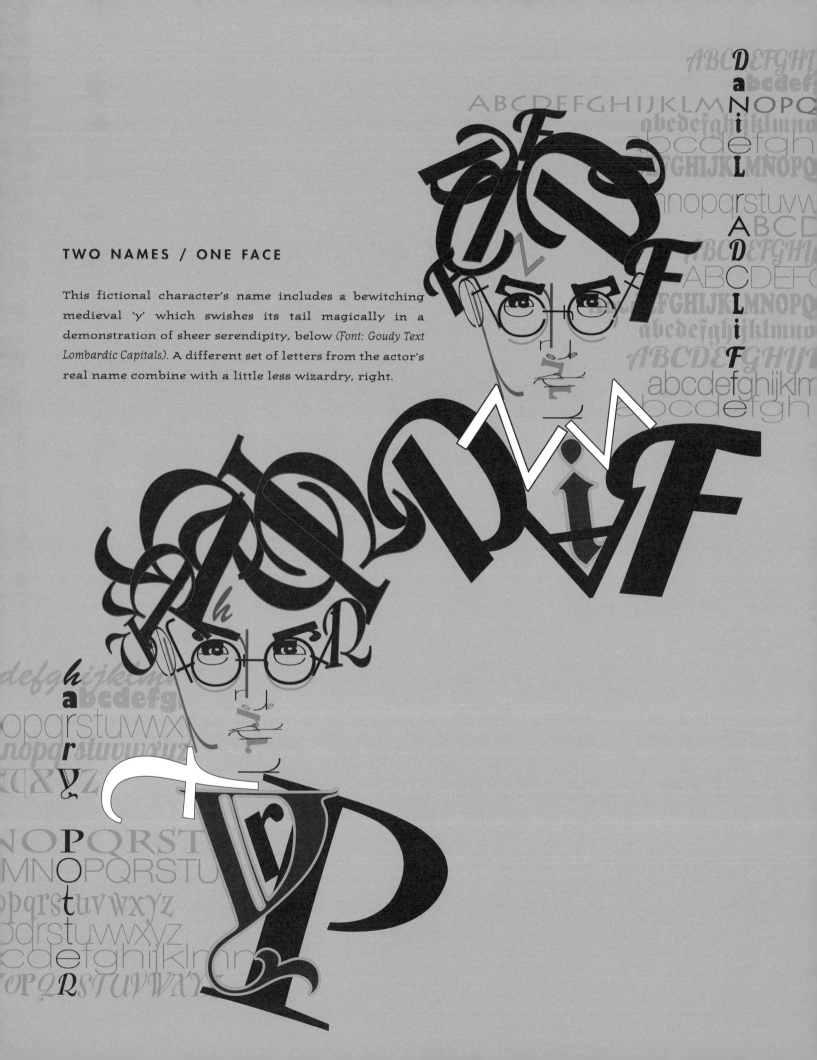

TWO NAMES / ONE FACE

This fictional character's name includes a bewitching medieval 'y' which swishes its tail magically in a demonstration of sheer serendipity, below *(Font: Goudy Text Lombardic Capitals)*. A different set of letters from the actor's real name combine with a little less wizardry, right.

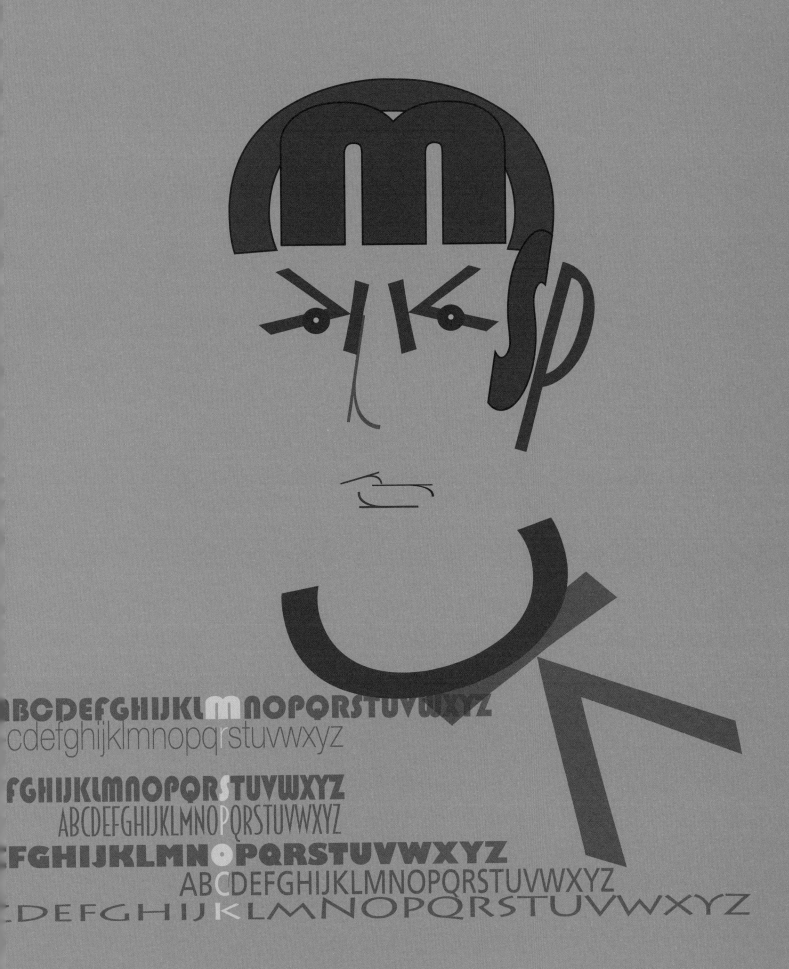

ABCDEFGHIJKLMNOPQRSTUVWXYZ
cdefghijklmnopqrstuvwxyz

FGHIJKLMNOPQRSTUVWXYZ
ABCDEFGHIJKLMNOPQRSTUVWXYZ
FGHIJKLMNOPQRSTUVWXYZ
ABCDEFGHIJKLMNOPQRSTUVWXYZ
CDEFGHIJKLMNOPQRSTUVWXYZ

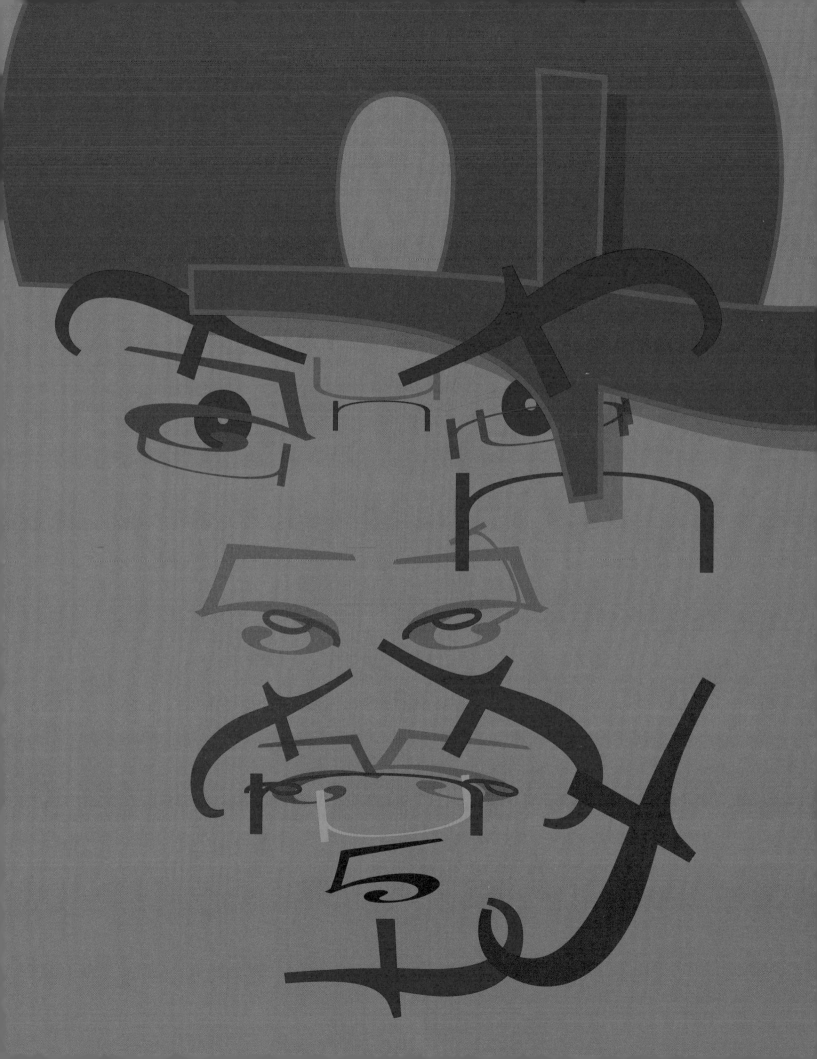

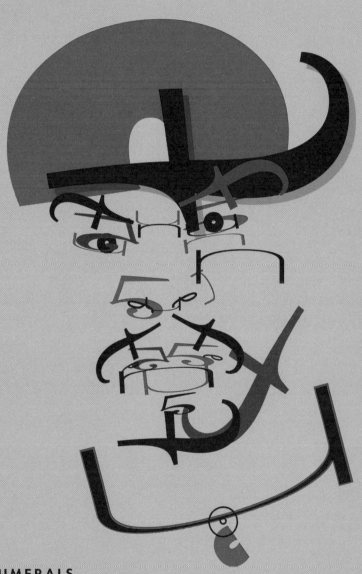

NUMERALS

Built from a blend of letters and numbers, this face is also a blend of the pragmatic and the eloquent. Simple sans serif shapes for '0' (zero) and 'C' (*Font: Gill Sans Ultra Bold*), and for 'e' (*Font: BlockBuster Sans*) and 'n' (*Font: Helvetica Neue 25 Extended*) are contrasted by the much sexier, serpentine curves of the numeral '5' and letter 't' that give eyes, lips and facial hair such performance-level flair (*Font: Fontesque*).

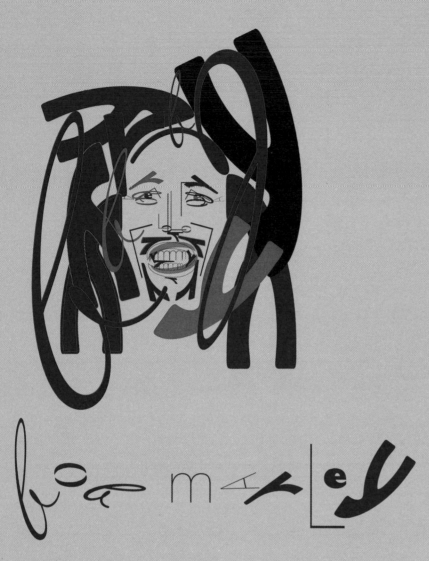

FLO MOTION / HOBO

In this happiest of faces, a broken capital 'O' is rendered in two interrupted arcs (Font: Flo Motion) which when further condensed, add a taught, stretched-wide smile to the lines of both eyes and mouth. A swirl of leaping dreadlocks is constructed mostly from a ropey lowercase 'y' (Font: Hobo). Created by Morris Fuller Benton in 1910, Hobo is unusual in that the lowercase has no descenders, and the entire font has no straight lines at all which, for this portrait, seems ideal.

O y abcdefghijklmnopqrstuvwxyz
Hobo
ABCDEFGHIJKLMNOPQRSTUVWXYZ
FLO MOTION

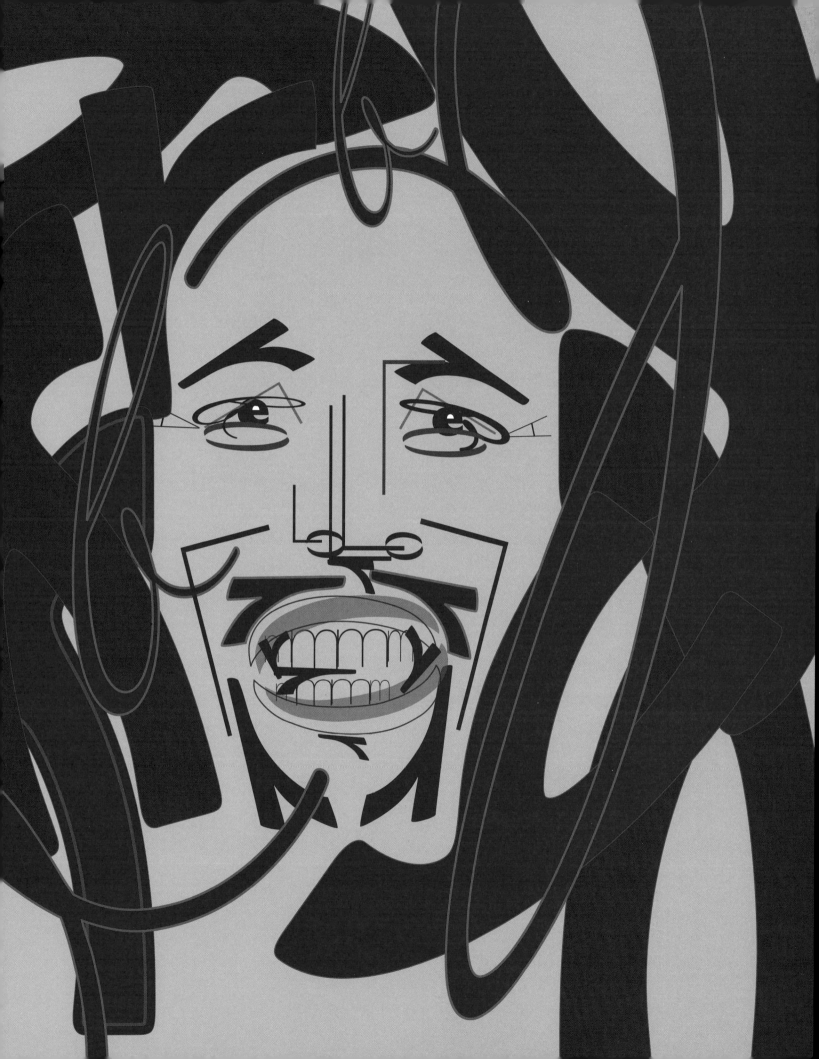

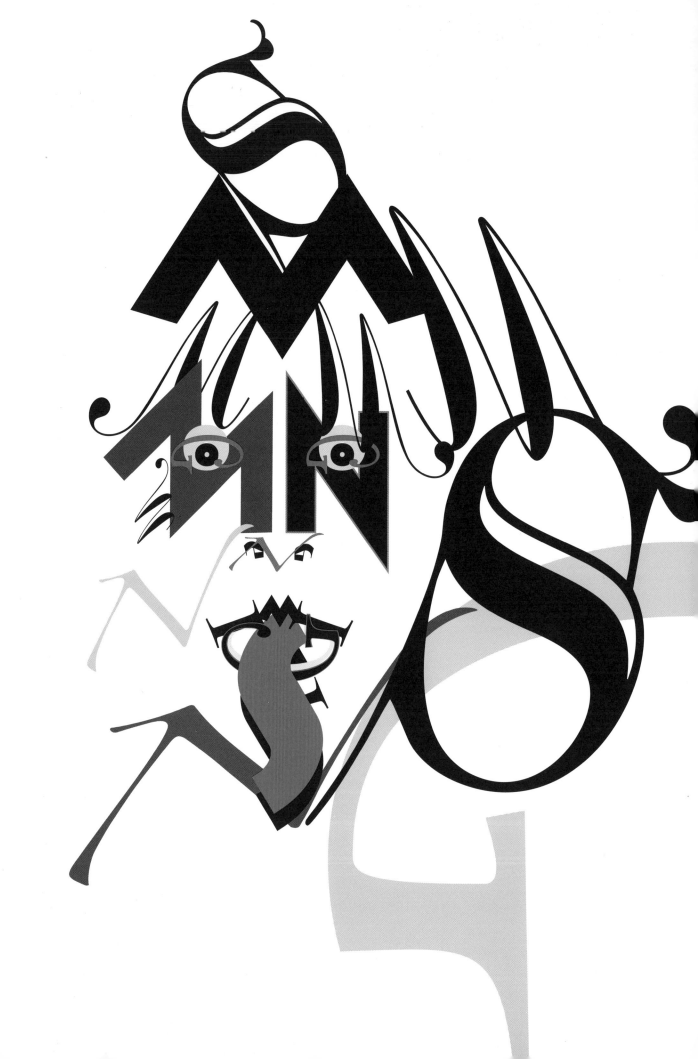

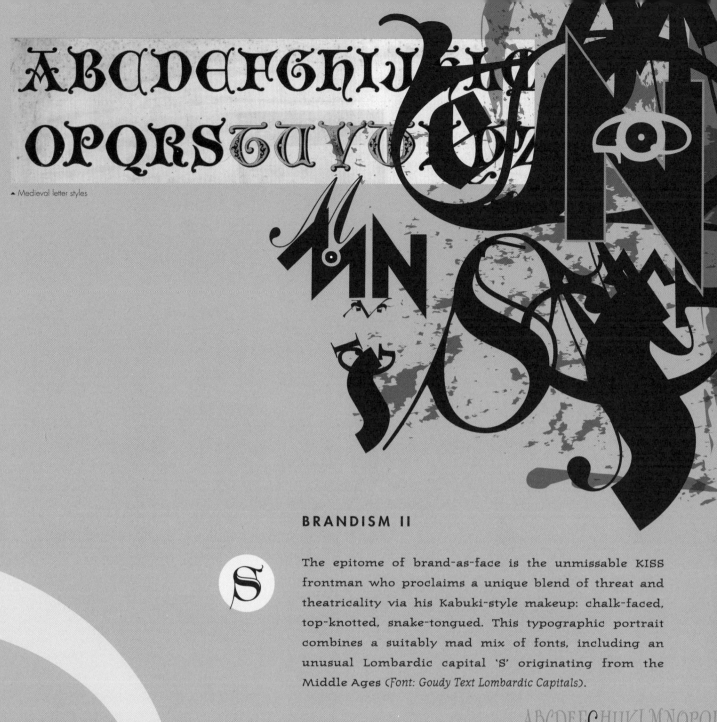

BRANDISM II

S

The epitome of brand-as-face is the unmissable KISS frontman who proclaims a unique blend of threat and theatricality via his Kabuki-style makeup: chalk-faced, top-knotted, snake-tongued. This typographic portrait combines a suitably mad mix of fonts, including an unusual Lombardic capital 'S' originating from the Middle Ages (*Font: Goudy Text Lombardic Capitals*).

STYLE TRANSFER

Casual script letters 'D' (*Font: Kaufmann*), 'Y', and 'l' (*Font: Amethyste*) outline this portrait. Designed in 1936, Kaufmann contains smooth, linking letters that have a constant, monoline stroke weight, ensuring they join up evenly like connected writing. By contrast, Amethyste letters are not designed to connect, and the variation in line weight gives calligraphic light and shade.

Designed by Georges Vial, Amethyste was one of the very first typefaces created exclusively as Typophane Transfer Lettering sheets in 1954 for Paris type founderie Deberny & Peignot. Typophane was the precursor to the highly popular Letraset dry rub-down transfer lettering, launched in 1961 in the UK. Letraset (and its French equivalent Mecanorma) became an indispensable tool of graphic designers until computers led to the digitisation of such font libraries in the late 1980s.

Kaufmann

Amethyste

ABCDEFGHIJKLMNOPQRSTUVWXYZ
ABCDEFGHIJKLMNOPQRSTUVWXYZ
ABCDEFGHIJJZ
ABCDEFGHIJKL
ABCDEFGHIJKLMNO
abcdefghijklmno
ABCDEFGH
FGHIJKLMNOP
abcdefghij
lmnopqrstuvw
ABCDEFG
PQRSTUVWX
lmnopqrstuvw
RSTUVWXYZ

ECCENTRICS

A relaxed lowercase 'f' draws this famous brow (Font: Textile),
and Tuscan capitals 'O' and 'D' add ornamental Mexican folk
art detail (Font: Calavera Two).

SIMPATICO

A voluptuous sans serif 'B' creates both décolletage and
lips in this portrait (*Font: Lithos*). The same font also contains
a curvaceous 'Y'-shape that can be applied to cleavage,
brow and chin. The happy inclusion of an acute above the
final 'É' delivers extra eyelash flutter (*Font: Bickley Script*).

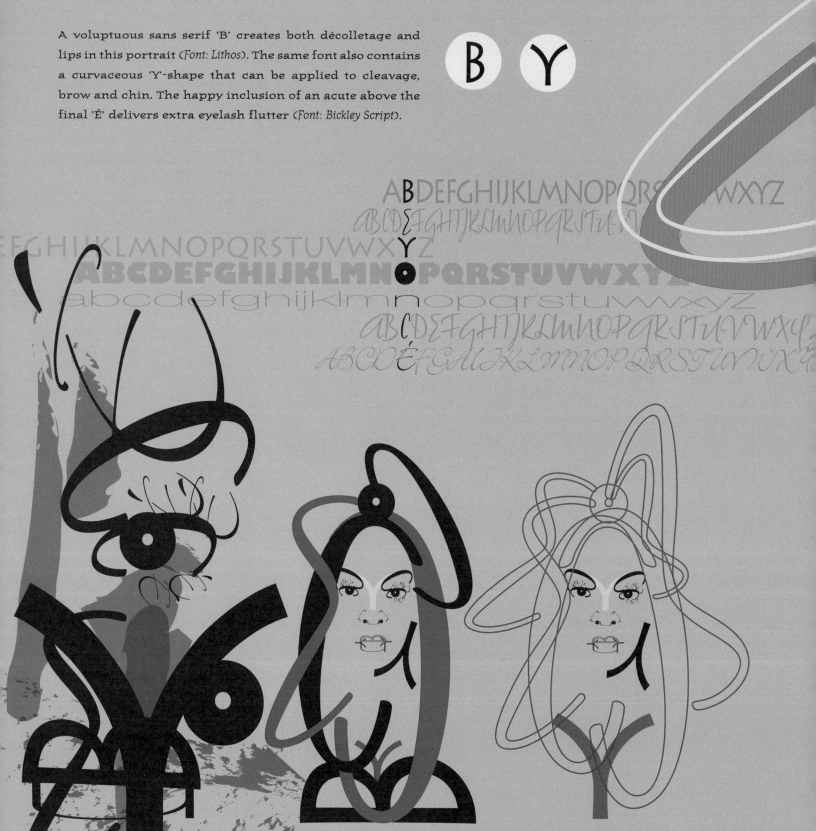

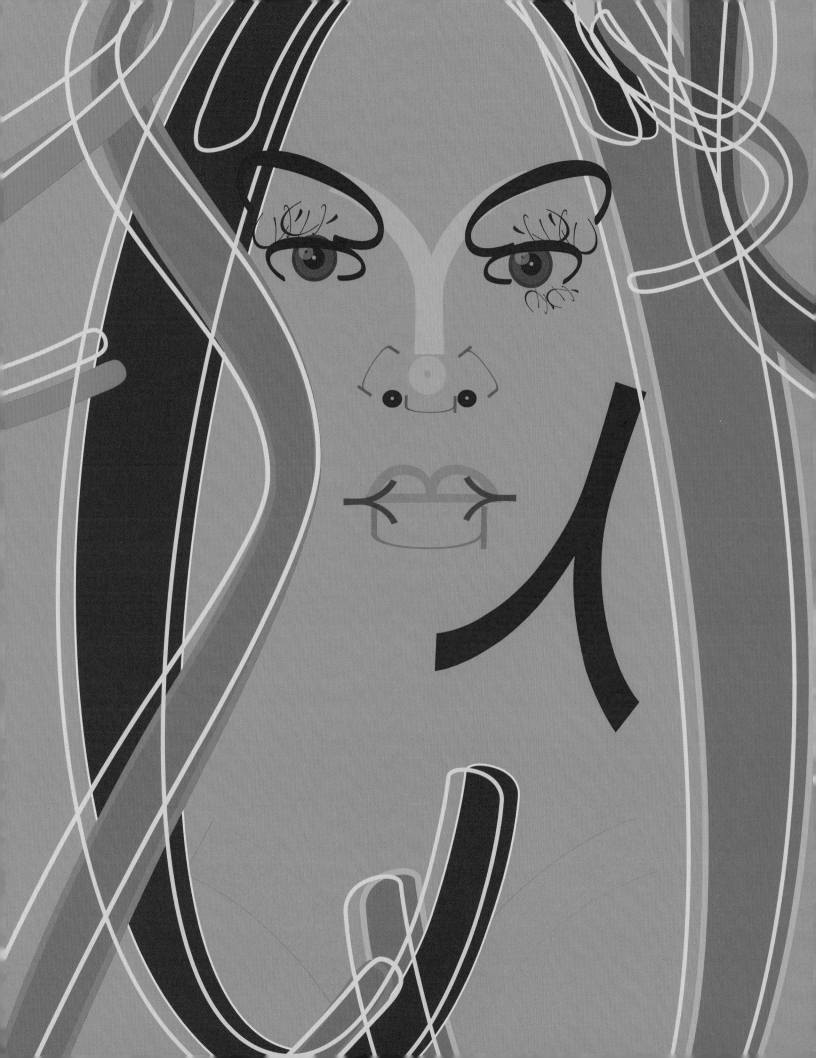

SOUVENIR

The fonts in this portrait are a blend of the extravagant and the familiar, much like the subject. A flamboyant 'E' for high collars (*Font: Linoscript*) and an 'O' from any novelty typeface for spectacular specs will spell the extrovert (*Font: Calavera Flaca* opposite, or *Dotline Regular*, above). But the basics of this face (L,j,h,n) are successfully rendered in either the simplest sans serif (*Font: Helvetica Neue 25*, above), or in the friendliest serif font of them all, Souvenir (*Font: Souvenir*, opposite).

abcdefghijklmnopqrstuvwxyz
Souvenir

Souvenir was designed in 1914 by Morris Fuller Benton, and based on an Art Nouveau typeface Schelter–Antiqua, created by J.G. Schelter & Giesecke in 1905. Chosen as the logo font of SPAM processed meat in 1937, its rounded, approachable style was made ubiquitous by mass use of that product both during World War Two.

Souvenir was revived by American type designer Ed Benguiat in the 1970s at a time when thousands of fonts were suddenly made available through the advent of photo composition technology. But Souvenir itself was not popular, gaining a reputation for simply not being cool enough for the 1970s, when designers loved to hate it almost as much as they hated Comic Sans in the 1980s. Although rejected by most designers at the time, Souvenir remained a great favourite of Australian Alex Stitt, founder of The Jigsaw Factory, prolific animator and graphic designer, and creator of a suite of exquisite film and TV projects of the 1960s, '70s and '80s including movie *Grendel, Grendel, Grendel*, and community advertising campaigns *Slip, Slop, Slap* and *Life. Be In It*.

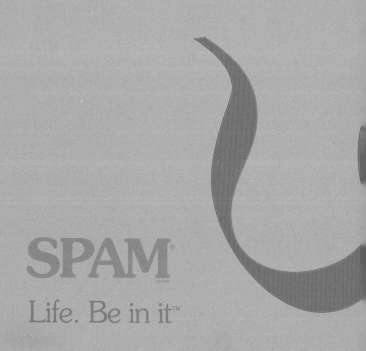

SPAM

Life. Be in it™

112

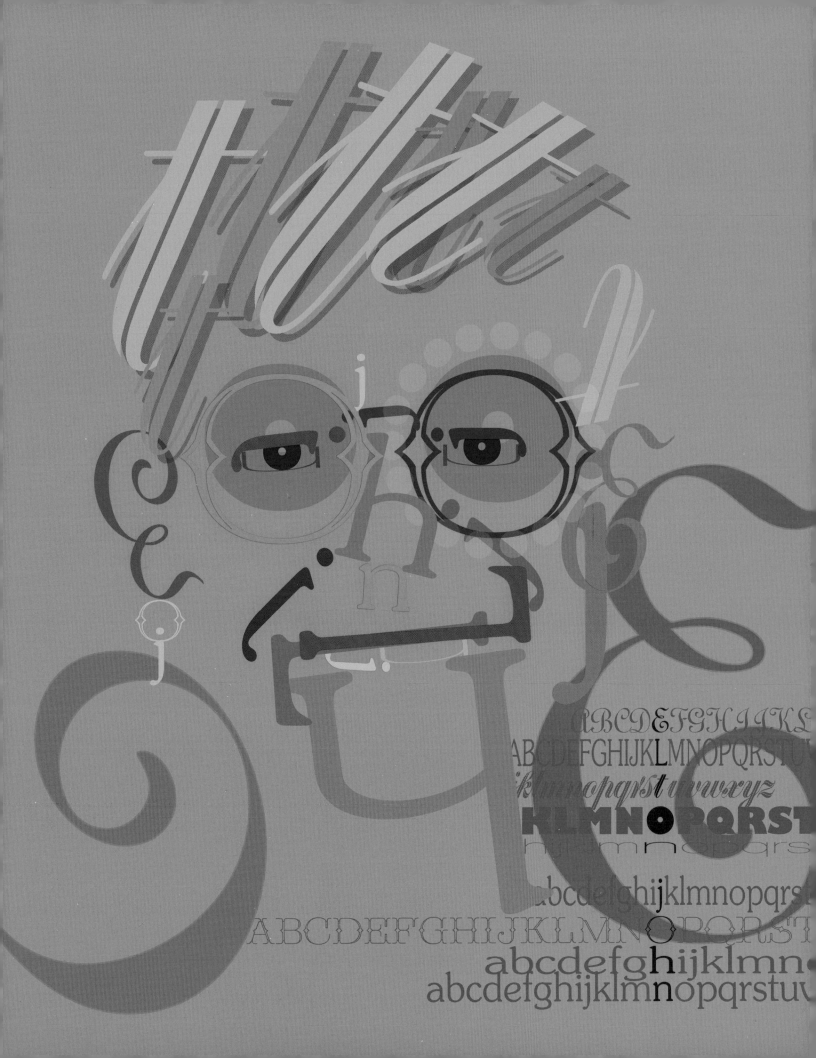

COLLABORATION/EXHIBITION

Content Creators Of Culture

▲CCOC Exhibitions: Kusama, Gaudi, Kaws and Picasso

▼ Exhibition: Alphabet City Zoo by Maree Coote
CCOC: Curator: Lee Eun-Hwa, Art Director: Sabina Lee
Exhibition Host : MBC,Daegu
Special Exhibition Centre, M House, MBC, Daegu

Content Curators of Culture (CCOC) of South Korea delivers unique interactive art experiences for a variety of audiences. Founded in 2013 by Director Kang Wook, CCOC has presented the work of Yayoi Kusama, Antoni Gaudi, Kaws and Pablo Picasso among many others. Their art is transformed into immersive experiences in gallery halls enlivened by the inspired staging ideas of CCOC Curator Lee Eun-Hwa, Art Director Sabina Lee, and Project Manager Jay Cho.

Kang Wook seeks out the unexpected, and his search for new and creative ideas ranges far and wide, recently including the world of children's book illustration. Such work is held in very high regard in South Korea, where the genre is nurtured and celebrated as the very foundation of literacy and creativity. Indeed, Seoul is home to the Nami Island International Children's Book Festival, and the island's celebrated artist and founder, Kang Woo-hyun, is a long-time collaborator of CCOC.

CCOC also works closely with the Munhwa Broadcasting Corporation (MBC), partnering in exhibition spaces and events. In its role as official 'broadcaster of culture', MBC is required by its charter to actively bring global ideas of varying scale, content and style into South Korea to educate, elevate and delight the South Korean people.

In 2018, Kang Wook and MBC culture director Seo Young-Jin attended the peak global showcase of children's book illustration, the annual Bologna Ragazzi Fiére in Italy. Here they discovered Maree Coote's award-winning Letter Art.

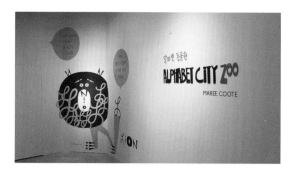

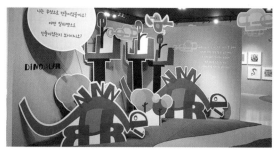

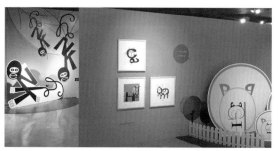

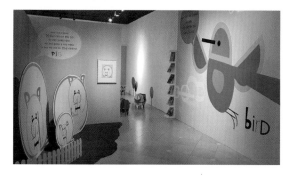

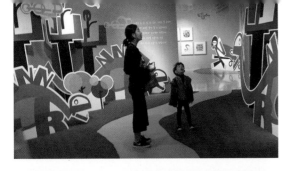

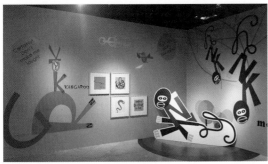

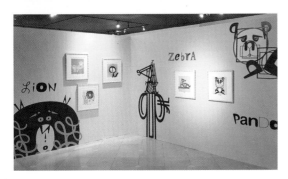

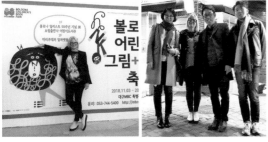

▲ Exhibition entrance
▲▶ Maree Coote with Lee Eun-Hwa, Kang Wook and Jay Cho of CCOC

▼ Sculpture submission, Melbourne, 2021

'It was creative and amazing that the alphabet created things around us, including people and animals', says Kang. 'We turned over the pages of *Alphabet City Zoo*, fell in love with her book, and thought we should introduce these works to children in Korea.'

And so in 2018/2019, and in partnership with the Bologna Illustrator's Exhibition, the CCOC team launched a major survey exhibition of children's book illustration, presenting a retrospective show of the Bologna Fiére from 1967–2015 entitled: '50 Years of Bologna International Children's Picture & Book Festival', held in the MBC gallery space in Daegu. The featured guest exhibition was 'Alphabet City Zoo by Maree Coote'. Invited to Korea in the role of docent, Coote presented lectures and workshops to students from pre-school to graduate level.

The exhibition itself was designed with the intention of drawing a young audience into the work and into the English language via Coote's Letter Art. Alphabet City Zoo included freestanding 3D cut-outs, bringing this typographic menagerie to life across multiple installation rooms. Curator and designer Lee Eun-Hwa explains: 'We wanted the world in Maree's book to unfold in real life like a pop-up book. So we made the characters from the book three-dimensional, allowing the audience to stroll through her book and meet alphabetical animals. The exhibition in Daegu was successful and many Koreans fell in love with the work.'

The exhibition was subsequently toured to Seoul in 2019 and 2020, and to the Dongdaenum Design Plaza in 2021.

FONTS, PROVENANCE & CREDITS

This book is typeset in Journal Ultra & *Journal Italic* (Designer: Zuzana Licko, 1990), **FUTURA HEAVY** & FUTURA BOOK (Designer: Paul Renner, 1928) and RALEIGH GOTHIC CONDENSED (Designer: Morris Fuller Benton, 1935).

Every effort has been made to correctly source font provenance. (In the world of type design, many typefaces are directly inspired by earlier designs and remade for newer applications, mediums and technologies, usually slightly altered in the process. Remakes are often given entirely new names, or named after the re-maker. And so the world of fonts is filled with what renowned sign painter and type designer John Downer (USA) variously calls: 'Revivals, Recuttings, Reclamations, Surveys, Remixes, KnockOffs, Clones, Counterfeits, Reinterpretations, Homages, Encores, Extensions, Spinoffs, Variations, Caricatures, Parodies [and] Burlesques'.[10])

FONTIGRAMS in this book are inspired by letters from various fonts including but not limited to:

Amethyste (Designer: Georges Vial, 1954; revived by Dave Farey, 1993)

Avant Garde (Designers: Herb Lubalin, Tom Carnase et al, 1970)

Bauhaus 93 (Designers: Ed Benguiat and Vic Caruso, 1975)

Berzell (Designer: Thomas Finke, 1991)

Bellevue (Designer: Gustav Jaeger, 1986)

Bickley Script (Designer: Alan Meeks, 1986)

Biffo (Designer: David Marshall, 1964)

Brush Script (Designer: Robert E. Smith, 1942)

CALAVERA (Designer: Oscar Yáñez, 2012)

Commercial Script (Designer: Morris Fuller Benton, 1906)

Cooper Black (Designer: Oswald Cooper, 1922, inspired by **Auriol Black**, 1903 and **Robur**, 1907, Designer: Georges Auriol)

Fette Fraktur (Designer: Johann Bauer, 1850)

Fontesque (Designer: Nick Shinn, 1994)

Flo Motion (Designer: Peter Saville, for Neville Brody's Fuse Project, 1992)

FUTURA (Designer: Paul Renner, 1927)

Gill Sans Extra Bold (Designer: Eric Gill, 1928)

Greyton Script (Designer: Gerhard Schwekendiek, 1991)

HERMOSA (Designer: Richard Beatty, 1991)

Helvetica (Designer: Max Miedinger, 1957)

HERCULANEUM (Designer: Adrian Frutiger, 1990)

Hobo (Designer: Morris Fuller Benton, 1910/15)

Kaufmann (Designer: Max Kaufmann, 1936)

KLunder Script (Designer: Barbara Klunder, 1994)

Limehouse Script (Designer: Alan Meeks, 1986)

Linoscript (Designer: Morris Fuller Benton, 1905)

LITHOS (Designer: Carol Twombly, 1989)

Lobster (Designer: Pablo Impallari, 2010)

Sloop Two (Designer: Richard Lipton, 1994)

Ru'ach (Designer: Timothy Donaldson, 1990)

Souvenir (Designer: Morris Fuller Benton, 1914)

variex (Designers: Zuzana Licko and Rudy VanderLans, 1988)

Zapfino (Designer: Hermann Zapf, 1948/98)

ACKNOWLEDGEMENTS

My most grateful thanks for their kind permissions, generosity, guidance and advice to all designers, studios, agents and archives who assisted in the making of this book, including:

Alan Meeks, UK

Alexander Tochilovsky, Herb Lubalin Study Center, NY, USA

Barbara Klunder, Toronto, Canada

Bill Dawson, XK9.com, LA, USA

CCOC: Kang Wook, Lee Eun-Hwa, Jay Cho, Sabina Lee and Oh Seung-Woo, South Korea

Coca-Cola Amatil

Dave Farey, Housestyle Graphics, UK

The Duffy Archive Ltd., UK

Ford Motor Company, MI, USA

Huerta Tipográfica, Argentina

Jonas E. Herbsman Esq. Shukat, Arrow, Hafer, Weber & Herbsman, NY, USA

Linda Joy Kattwinkel Esq., Owen, Wickersham & Erickson P.C., CA, USA

MBC: Seo Young-Jin, Hwang In-Sung, South Korea

Milton Glaser Studio, NY, USA

Mindy Seu, Lubalin Archive, NJ, USA

Nick Shinn, Shinntype, Toronto, Canada

Oscar Yáñez, Mexico City, Mexico

Pablo Impallari, Impallari Type, Argentina

Seymour Chwast, Push Pin Inc., NY, USA

Timothy Donaldson, UK

Todd Interland, Interland Music, London, UK

Zuzana Licko/Emigre, CA, USA

THANKS

My thanks for their invaluable input, review and support to Lex Ridgeway, Ginger Ridgeway, Stefano Boscutti, Bill Wood, Jacqui Young, and to Diona Syme for pre-press.

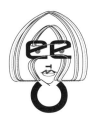

GLOSSARY

ascender: the part of a lowercase character that ascends above the x-height (e.g. the stems of letters k,h,d)

descender: the part of a lowercase character that descends below the x-height (e.g. the tails of letters g,p,y)

grotesk/grotesque: an early name for 'sans serif'

glyph: a letter shape; a represention of a character, number or symbol

italic: a sloped version of a Roman typeface (always angled to the right)

kerning: the finer adjustment of space between letters

leading: the finer adjustment of space between each line of type

ligature: a single glyph composed of two or more letters (e.g. ſt, ffl, Æ, æ, ﬆ)

lowercase: small letters (originally kept in the lower drawer of the typesetter's case); derived from minuscule letterforms

majiscule/minuscule: early terms for capitals and small letters

tracking: the averaged adjustment of space between letters across a line

sans serif: without serifs (see 'serif')

serif: small strokes that complete the arms, stems, tails or feet of letters

uncial: medieval majiscule letterforms, rounded and capital only

uppercase: capital letters (originally kept in the upper drawer of the typesetter's case); derived from majiscule letterforms

x-height: the lowercase 'x' height is the metric that determines font size

FOOTNOTES

1. Bill Dawson, *Typethos: Thoughts on Type from Type People*, https://www.XK9.com/typethos.

2. Nick Shinn, *Undead: Being a Discourse on the Nature of Gothic and a Specimen of the type Merlin*, Canada, 1997, p.7.

3. The first printing from wooden blocks dates to Suy Dynasty, China, c.550AD. Moveable type using porcelain units was invented by Bi Sheng in c.1040 in China's Ming Dynasty. The first metal moveable type originated in Korea in 1377. In the West, Germany's Johannes Gutenberg created moveable type and the printing press in 1450.

4. Petra Eisele, Annette Ludwig, Isabel Naegele, *Futura: The Typeface*, London, 2016, p.228.

5. Simon Loxley, *Type: The Secret History of Letters*, New York, 2004, p.154.

6. Eisele et al, op.cit., p.231.

7. Ibid, p.236.

8. Single case or 'unicameral' font enthusiasts include Herbert Bayer, a member of the Bauhaus School who created his Universal typeface in 1925, and American Bradbury Thompson, who created a 'monoalphabet' called Alphabet 26 in 1958.

9. Barbara Klunder, https://www.fontshop.com/families/ff-klunder-script.

10. John Downer, *Call It What It Is*, First pub. Tribute, 2003, accessed online at https://www.emigre.com/Essays/Type/CallItWhatItIs.